THE DAY OF THE DEAD
DRAWING BOOK

THE DAY OF THE DEAD
DRAWING BOOK

LEARN TO DRAW BEAUTIFULLY FESTIVE MEXICAN ART

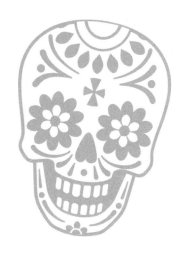

MADDY BROOK

ARCTURUS

ARCTURUS

This edition reprinted in 2019 by Arcturus Publishing Limited
26/27 Bickels Yard, 151–153 Bermondsey Street,
London SE1 3HA

ISBN: 978-1-78888-214-9
AD006390US

Printed in China

CONTENTS

PROJECTS 15

INTRODUCTION

The Day of the Dead is a Mexican celebration held over a couple of days in early November every year. The holiday is mainly practiced throughout Mexico and by people of Mexican descent living in other places, particularly the United States. It is known throughout the world and is characterized by its bright colors, costumes, parades, food, drink, and art.

The holiday reflects on the lives of loved ones who have died and celebrates their journey back home from the spirit world. People visit cemeteries to be with the souls of lost friends or family members and build private altars (*ofrenda*), which often contain the departed's favorite foods, as well as photos, memorabilia, and flowers. Orange marigolds are said to attract the souls of the dead to the offerings.

The aim of the Day of the Dead is to encourage departed souls to visit, so they can hear the prayers and the words of the living. A common symbol of the Day of the Dead is the skull (*calavera*) and celebrants represent this with decorative masks and themed foods, such as sugar skulls, which can be given as gifts to both the living and the dead.

The art of the Day of the Dead is full of patterns, flowers, and, of course, skeletons! This book will teach you, step-by-step, how to create intricate Day-of-the-Dead-inspired illustrations, including Monarch Butterflies (pages 48–53), a Skeleton Dog and Cat (pages 66–71), Dancing Skeletons (pages 78–83), and even your very own Skeleton Mariachi Band (pages 90–95).

The simple instructions are suitable for beginners—you don't need to be a professional artist, just pick up this book, a pad of paper, and a pencil and start drawing! The book will walk you through every stage of an image, from beginning to end, and will teach you how to add all sorts of fun and fantastic details and decorations to your illustrations. Along the way, you will also learn some of the fascinating history and traditions associated with this holiday.

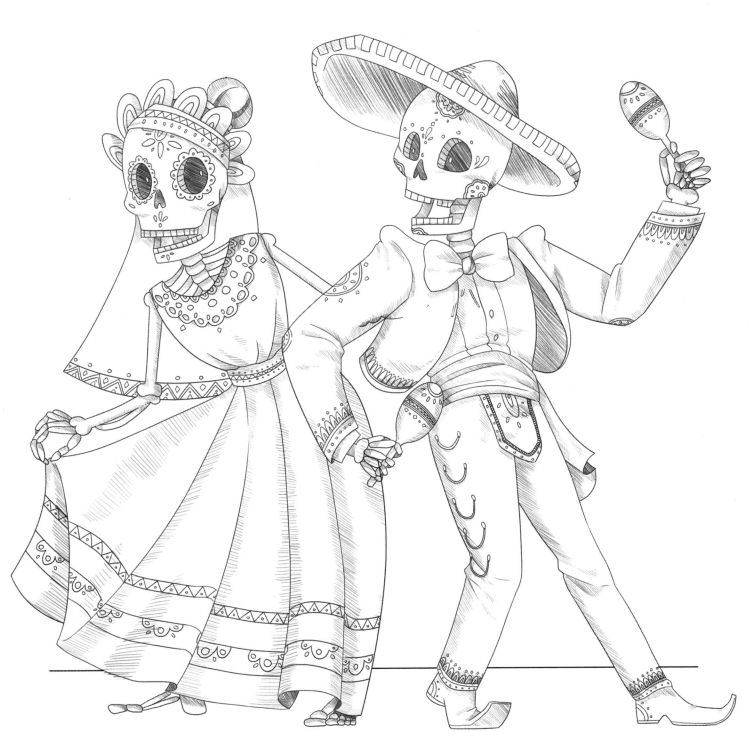

MATERIALS

Before you start, you will need to gather together some basic materials in order to create your Day of the Dead illustrations. A pencil, an eraser, and some paper will be your go-to supplies, as well as a few other simple items to help you along the way. These materials don't have to be expensive. Before you go out and buy supplies, have a look around your home for equipment you might already have!

PENCILS

The types of pencils you use can give different effects to your illustrations. For beginners, it's best to pick something quite neutral to start with, and then you can expand your repertoire once you get the hang of drawing.

- **Standard wooden pencils**
 The most common pencil you're likely to find is an HB graphite pencil. You can sharpen it or let it go blunt for different effects. Wooden pencils range from very soft to very hard:
 - Soft
 Soft pencils range from HB to 9B and are darker and easier to blend than H pencils. You can use these to shade in large areas and to block in tones in your illustrations.
 - Hard
 Hard pencils range from HB to 9H and are used for more precise, neat lines. These are better to crosshatch with and to shade in small areas.

- **Mechanical pencils**
 I like to use mechanical pencils when I draw because they don't tend to get as blunt as wooden pencils and you don't need to sharpen them. They make clean, neat lines and come in a variety of hardnesses and thicknesses.

ERASERS

Erasers are very handy for these illustrations, which all have guidelines that will need erasing. There are two types of erasers that you will need:

- **Kneadable erasers:**
 These are soft and pliable with a texture similar to adhesive putty. Use them to lightly erase lines or areas you have shaded. They are neat because you can work them into whatever shape you need.

- **Hard-edged erasers**
 These are perfect for fully erasing pencil marks and for more precise erasing. Cut them with a sharp knife to get a nice edge for details, or use the flat edge to erase a large area at once.

Take care not to rub too vigorously with both types of erasers, otherwise you might damage your paper!

PAPER

Paper is a vital part of drawing, as it's what you draw on! There are so many variations, which might be overwhelming to choose from, but try some different types to see what works best for you.

- **Paper pads**
 For beginners, I would recommend a sketch pad with a medium-weight and light textured paper. Go for a book with lots of sheets, so you can start over on a fresh sheet when you need to. Look for a paper thickness of 100 gsm without a lot of texture. I would recommend an A4-sized book, so you have plenty of page room to work with, but the book is still portable.

- **Tracing paper**
 Tracing paper is handy for transferring a drawing onto another surface or piece of paper. You can also use it to reverse an image and make a pattern. It is transparent, so you can place it on top of your guidelines and still see them.

OTHER MATERIALS

- **Pens**
 Pens are another common drawing tool. You can't erase pen lines, so they may not be the best tool for sketching, but you can use them to make your outlines darker. Once you have finished an illustration, you can cover the outlines of your pencil marks in pen and then erase the pencil lines. Your pen marks will remain in place.

- **Pencil sharpeners**
 Sharpeners are used to make the points of your wooden graphite pencils sharp. It's best to buy a good-quality sharpener so it doesn't ruin your pencils.

- **Rulers and compasses**
 Although you don't need to make perfect lines and shapes for these illustrations, it might help you to have a ruler and a compass to make straight edges and neat circles where needed.

SHAPES

Use the following shapes as the basic building blocks with which you can start your drawings.

ELLIPTICAL SHAPES

Elliptical shapes are used as guides for heads and moving joints in figures, and for other round or oval objects.

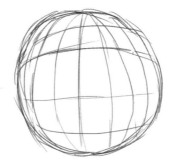

RECTANGLES AND SQUARES

Rectangles and squares are good to use along with elliptical shapes to make cylinders, and also for solid, box-like objects.

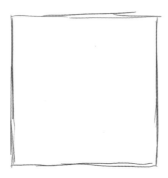
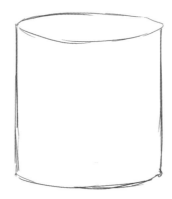

TRIANGLES

Triangles are used less frequently, but are good for feet and hand guides, as well as for wings and other three-sided objects.

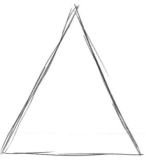

BASELINES

Most of the time, your figures won't sit directly on this baseline, but it helps to add in some perspective. You can draw this line in with a ruler or by hand, but it helps if your line is straight.

DECORATIVE SHAPES

I embellish my finished illustrations with a variety of decorative elements, such as swirls, teardrops, zigzags, and flowers. There are many different options that you can use; just add the basic shapes and keep layering.

SHADING

I prefer clean line shading over smudge shading. It gives the illustrations a sharper look.

LIGHT SOURCE

Before you begin shading your images, first imagine where the light in your illustration is coming from. This will determine where you put shadows and highlights and will help to give your image a more realistic and consistent look.

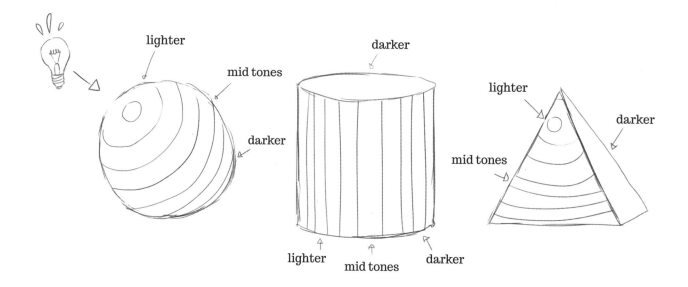

HORIZONTAL AND VERTICAL LINE SHADING

These lines work best when using a hard pencil and doing many quick, bold strokes with it in one direction. This will make one layer of shadow.

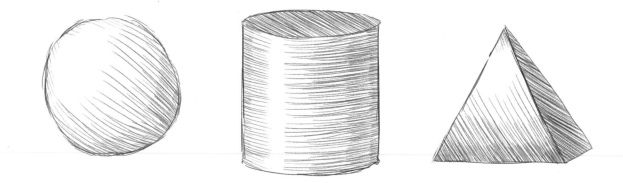

CROSS-HATCHING

Cross-hatching is almost the same as horizontal and vertical line shading, but once you have added strokes in one direction you go over your first layer of lines in the same way but at right angles. Repeat until the area is as dark as you want.

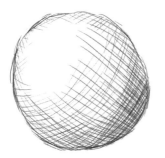 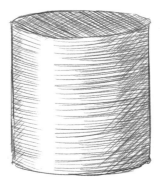

SMUDGING

If you want a softer look to your drawings, draw with a soft pencil and use your finger with a piece of tissue around it to blend out the pencil strokes. Continue until the area is as dark as you desire.

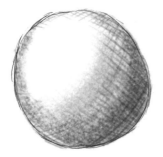 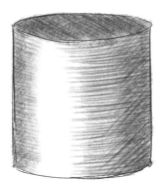 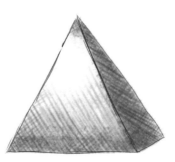

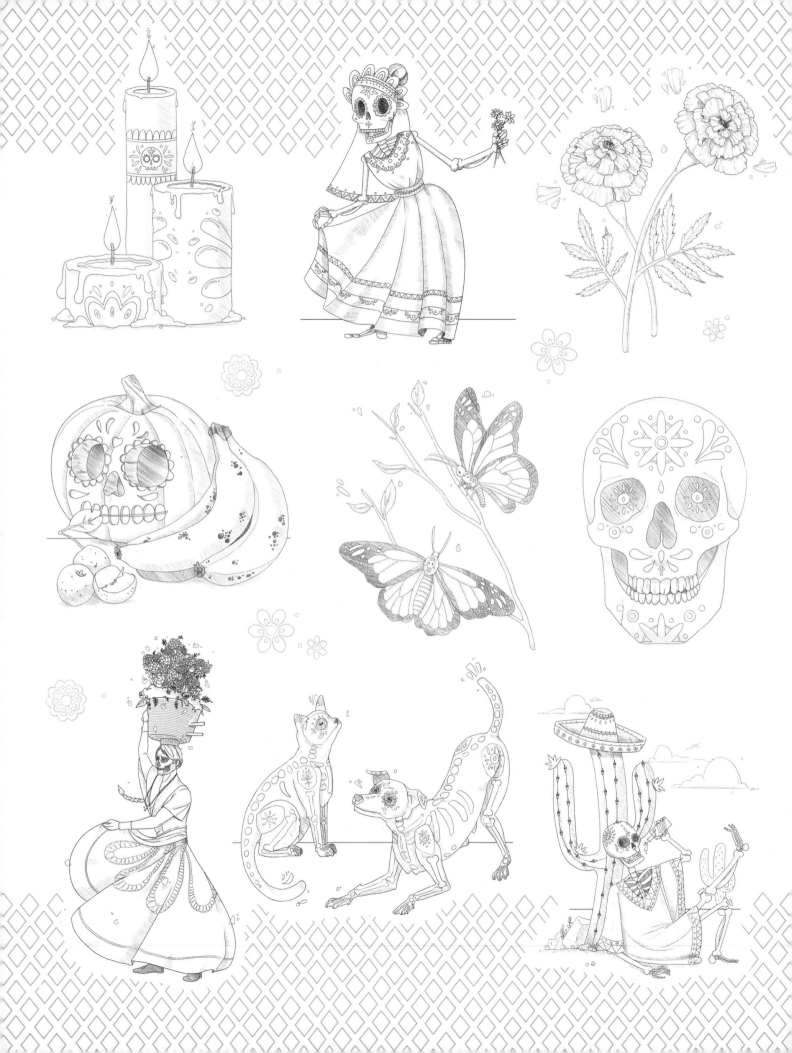

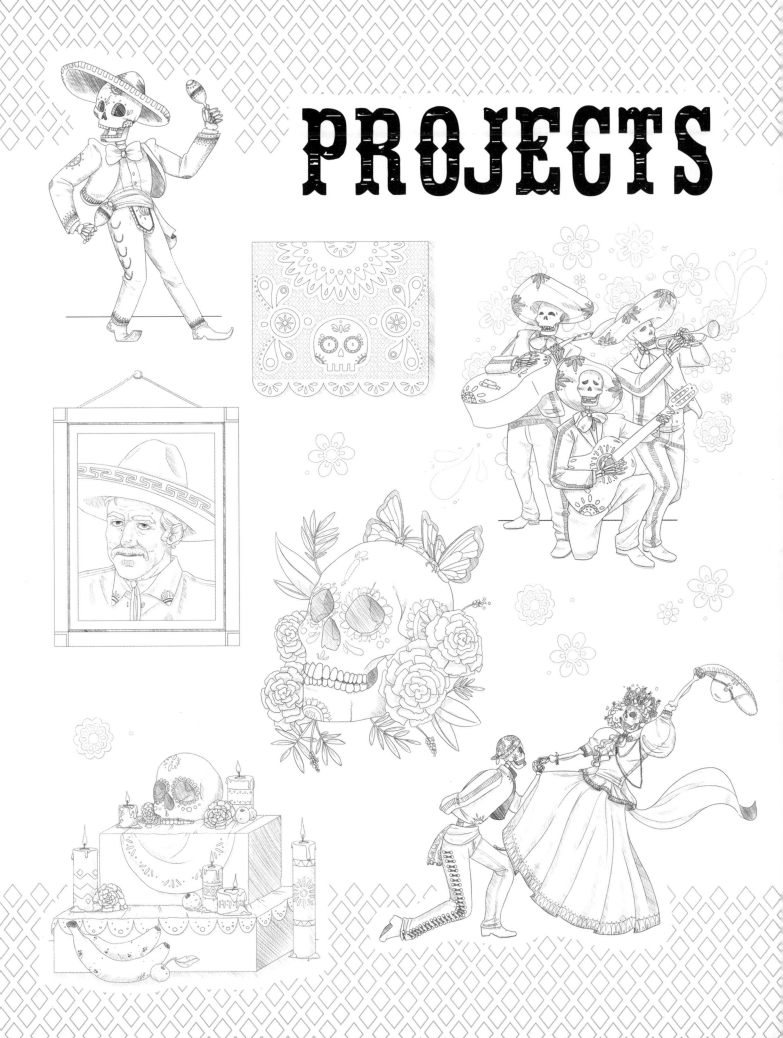

PROJECTS

SKULL

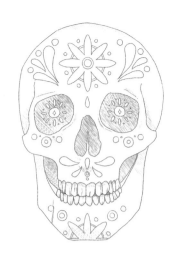

Images of skulls, or *calavera*, play an important role in the Day of the Dead festival and are depicted in many artworks centered around the celebration. They are decorated in bright, beautiful patterns and are often made from sugar and left as offerings for the deceased when they return home.

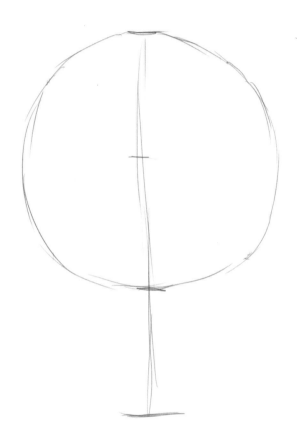

STEP 1

To start your skull, you will need to draw some basic guidelines. The base will be a circle. This guide circle doesn't have to be perfect, but you can use a compass or draw around a circular object for the circumference, if you like. Next, draw a vertical line down the center of the circle. This line will extend past the bottom, with the line segment that's outside the circle being about half of the circle's diameter. The bottom of this line will indicate where the skull's chin will be. Now add in four horizontal marks down your center line, marking it into thirds.

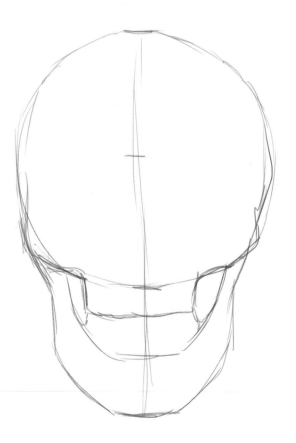

STEP 2

Once you have the basic guidelines in place, you can block in the jawline. It will start from the sides of the circle and come down at an angle, forming the cheekbones. When you get to the bottom of the circle, it will straighten out a little before curving around to meet the bottom guideline, forming the chin. The top part of the lower jaw (where the bottom teeth come out) will start at the bottom of the circle and follow the outside of the jaw in a "U" shape. The upper jaw will continue from the cheekbones and will come down at a sharp angle. Once you have drawn both of the jaws, you can add in where the teeth will go.

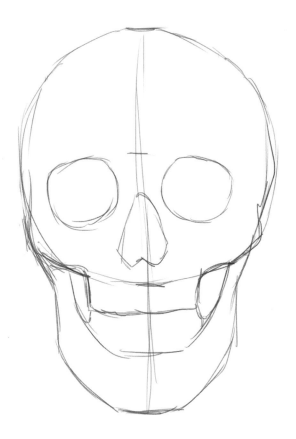

STEP 3

Now we can move on to the facial features. From the cheekbones, come in about one-third of the way toward the center line to start the eye sockets. The bottom of the eye sockets will start almost halfway between the second and third horizontal guidelines. The tops of the eye sockets will start just below the second horizontal line and they will finish closer to the center line. The nose cavity, which is triangular in shape, will go in between the two eye sockets, with the bottom of the nose starting above the third horizontal guideline.

STEP 4

Now your basic face shapes are in place, start to refine your illustration. You can begin to define the cheekbones further, bringing them up into the face, following the shape of the eye sockets. You can also add rectangular shapes for the teeth. If you have trouble, you can pull up a reference image or look in the mirror! The biggest teeth are in the middle of the face and they get smaller away from the center.

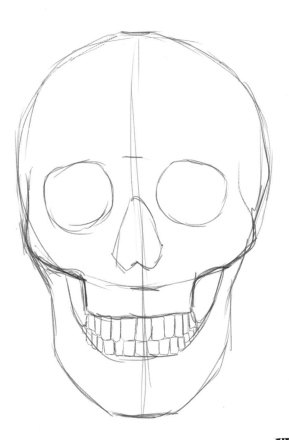

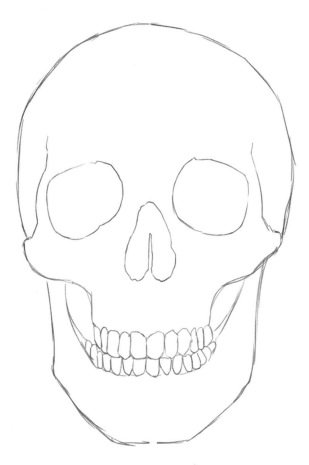

STEP 5

When you are happy with your under sketch you can erase the guidelines and outline and refine your shapes, rounding out any sharp corners. The teeth will become more rounded and shaped; some can be ragged, or even missing! You can add more detail in the nose, such as the line of bone that runs up the center the septum.

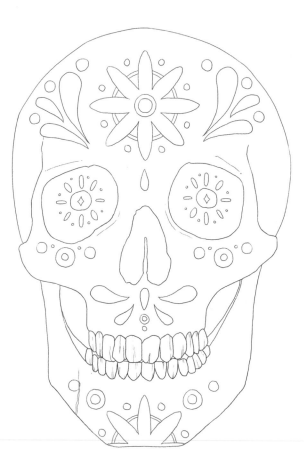

STEP 6

Now that you have your neat skull outline, you can add in some Day of the Dead decorations! You can decorate the skull however you want. Most often, the skull will have flowers, swirls, dots, and teardrop shapes as decorative elements. There are so many variations you can draw, so take your time and have fun! Finish with a little shading (see the final image).

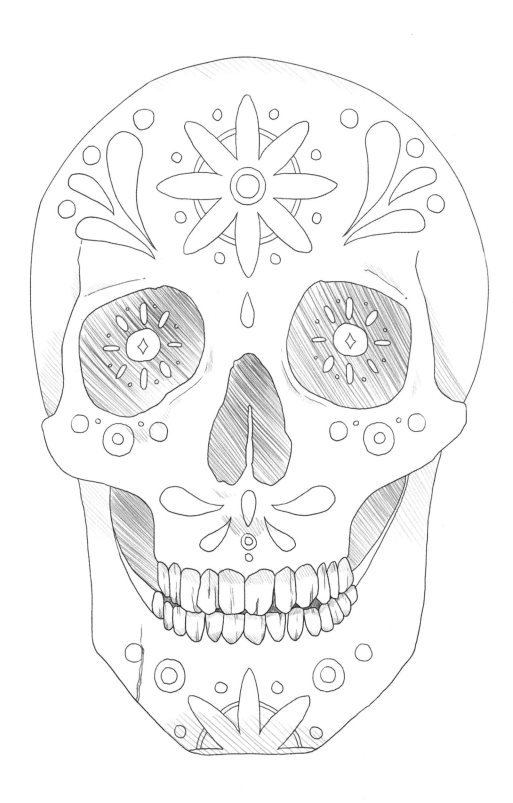

CATRINA

Catrina is probably the most famous *calavera* and a Day of the Dead icon. She is a joyful female skeleton, often dressed in early 20th century European clothing. Artists have made her figure from all sorts of materials including clay, papier-mâché, wood, paint, and of course, pencil and paper!

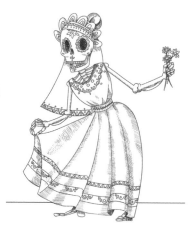

STEP 1

To start your Catrina illustration, draw in a baseline. You can then add in a movement line where you want your figure to stand. This line will represent your figure's spine, neck, and one of her legs. From there, you can sketch in a circle for her head and add in horizontal lines below this for her shoulders and hips.

STEP 2

Now that you have worked out where and how you want your figure to stand, you can began to block her out. To add in a rib cage, draw a "U" shape just below the shoulder line, extending about three-quarters of the way toward the hip line. The hips are made by drawing a peanut shape in the same place as the hip line. To add in arms, draw lines starting from the ends of the shoulder line, bending them midway and adding in circles for the shoulder, elbow, and wrist joints. The legs will work the same way. Sketch in triangle shapes for the hands and feet at the ends of your lines, and draw in the guides on the face for the features. You can also sketch in any props that your figure will be holding.

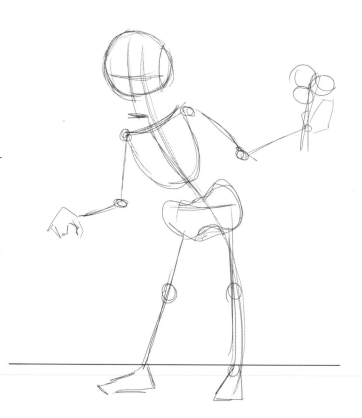

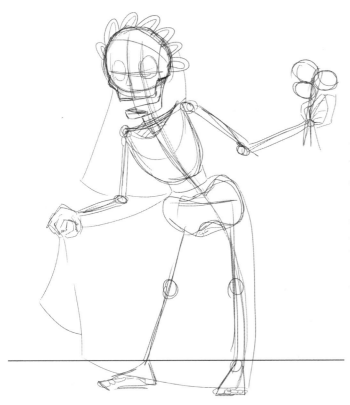

STEP 3

Once you are happy with how your figure is posed, you can block in her clothing; add in her eyes, nose, and other facial features; and began to sketch in the bones that won't be covered. While you are sketching out the clothing, bear in mind that loose clothing will hang from any point, will be pulled down by gravity, and will bunch up where two pieces of fabric meet. Some of the clothing will billow out and double over itself.

STEP 4

When your basic clothing outlines are complete, you can erase your guidelines and begin to add more details to the clothing, the props, and the arm bones, hands, feet, and chest. There are two bones in the forearm, which are called the radius and the ulna. The hands and feet are made up of many smaller bones. If you are having trouble drawing these, you can look at your own hands and feet to see where the joints are, or work from a reference image. Connect the skull to the rib cage using multiple small rectangular bones to form the spine. To draw the skull, refer back to the Skull illustration (see pages 16–19).

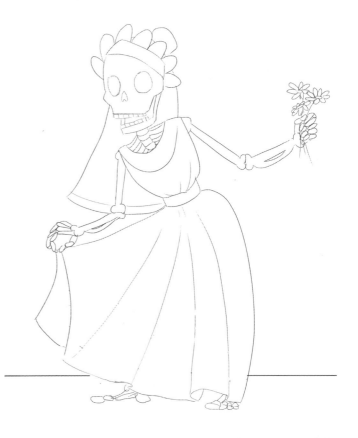

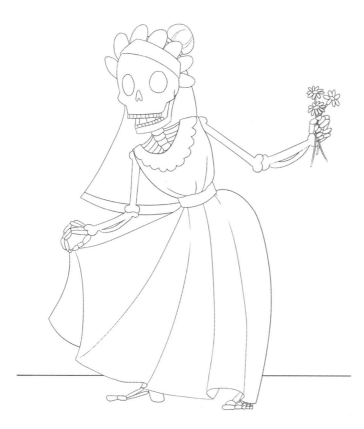

STEP 5

When you are happy with your how your illustration is looking, you can go back over your outlines and neaten everything up. Fill in some more details in the clothing and draw in some hair, if you wish.

STEP 6

Now that your figure is complete, it's time to add in some details to make your Catrina more festive! Decorate her dress and veil with patterns and embroidery elements. Adding shapes such as swirls, circles, and triangles in different ways will add more interest to your final illustration. You can add as much or as little detail as you want! Finally add shading. Notice how the dark shadows behind the eye sockets draw attention to the face (see the final image).

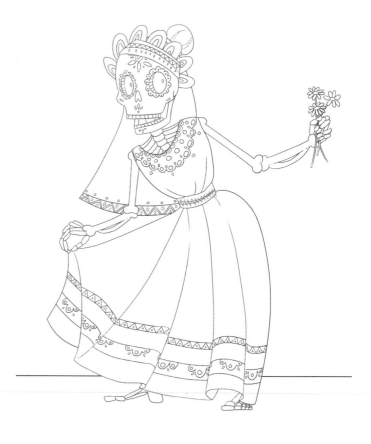

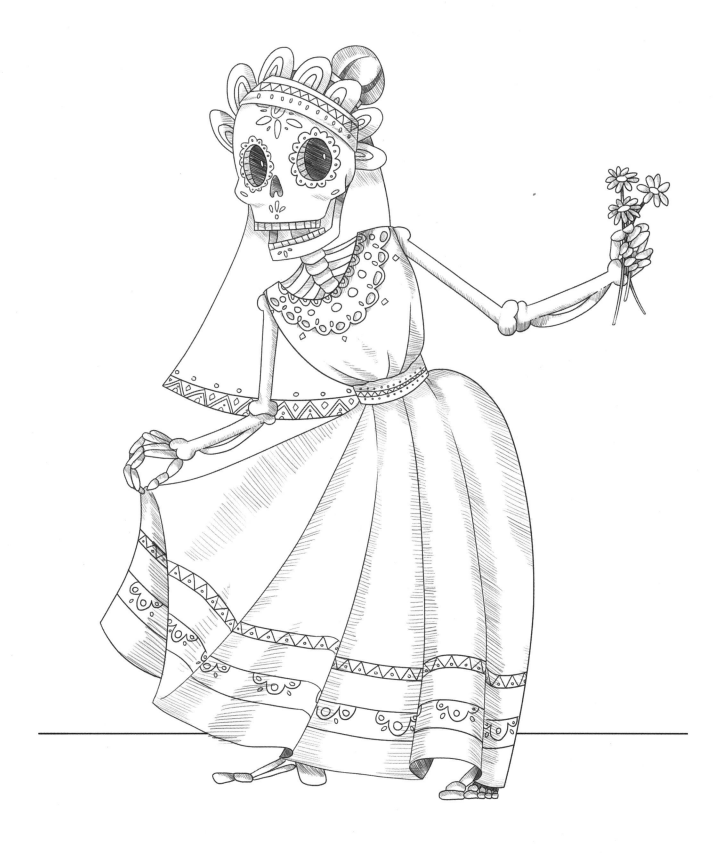

CATRÍN

Catrín is the male counterpart to Catrina. He is also a cheerful skeleton and is often dressed in a tuxedo and other fancy clothing.

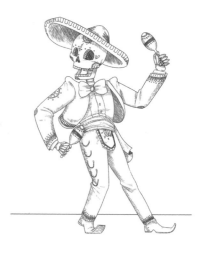

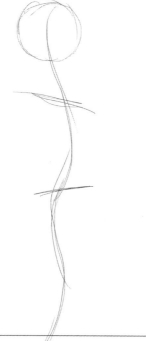

STEP 1

As with Catrina, sketch out a baseline first, then sketch out the basic pose you want your Catrín to be in. If you're stuck for ideas, you can always give him an instrument. Draw a movement line for your figure to follow; a curve in the spine helps to keep the pose dynamic. Sketch in where you want the shoulders and hips to be, and add a circle for the head.

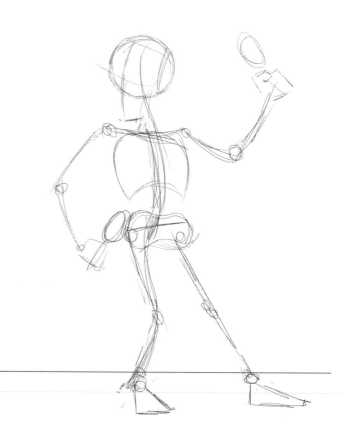

STEP 2

Now that you have your movement lines in place, you can begin to flesh out your pose. Draw in the rib cage and hips. The arms will extend out from the lines you have drawn for the shoulders, and the legs will extend out from the hip line. When you have the lines in place for the arms and legs, you can add in some circles for the elbows, wrists, knees, and ankles. Add in some triangles for the feet and basic shapes for the hands, and then sketch some guidelines on the circle for the face.

STEP 3

Now that you have your pose worked out, you can start to block in his clothing, adding in details such as belts and shoes, facial features, and any bones that are showing. You can also begin to work on any props in your image, such as instruments.

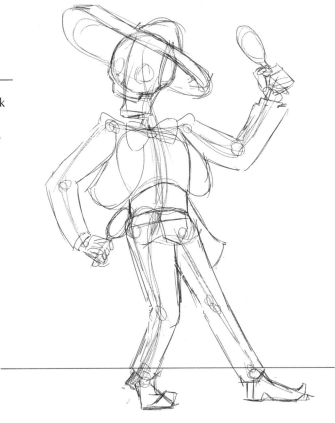

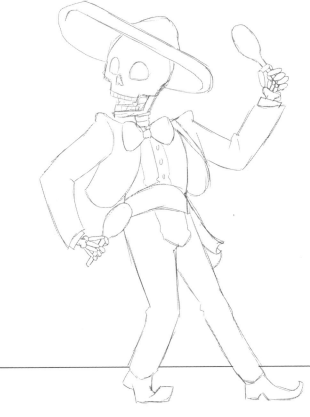

STEP 4

When you are happy with the shapes of the clothing you can erase your guidelines or grab a new piece of paper and trace Catrín out. Now go back in and start to add more details, such as folds in the belt and any creases in the clothing. Add lines to his shirt and fill out the shape of his sombrero. At this stage, you can add in more details to the facial features, hands, and neck, such as the teeth, fingers, and neck bones.

STEP 5

With your illustration completely mapped out, you can darken the outline and neaten up your lines. Erase any guidelines that are still showing.

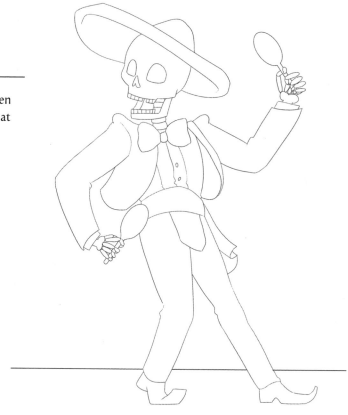

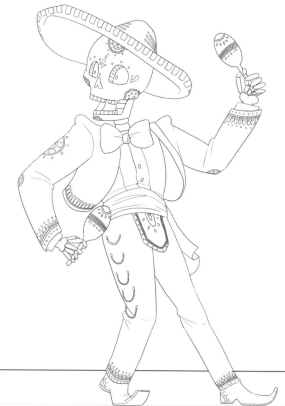

STEP 6

The last step in this illustration is to add in the details. You can decorate the cuffs of his jacket and pants, and add in piping and embroidery patterns all over his costume and sombrero. Draw some patterns on any props he is holding and on his face. Add shading to finish (see the final image).

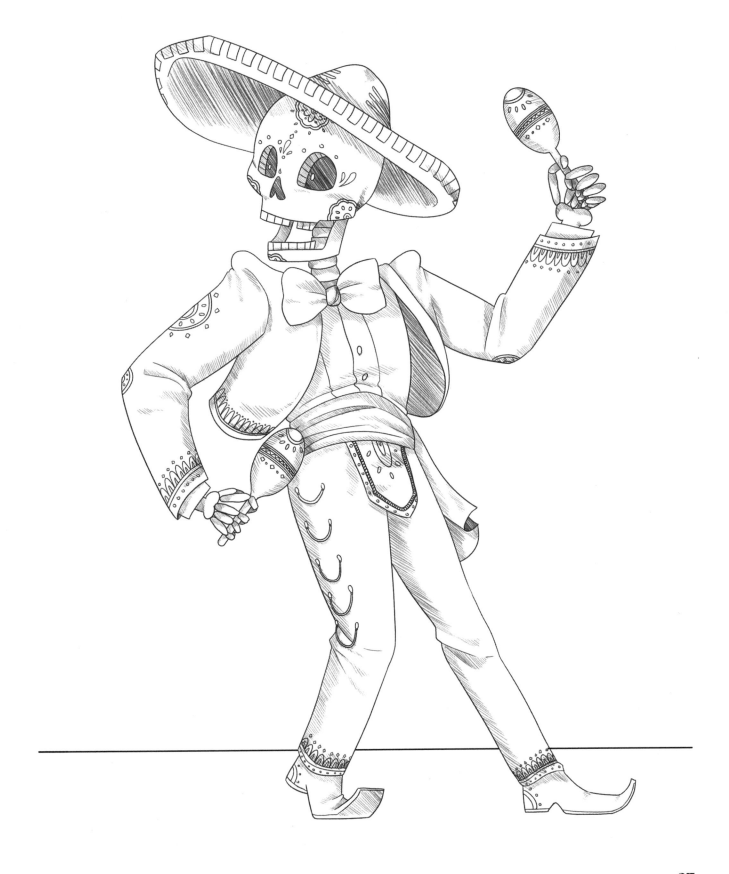

MARIGOLDS

Marigolds are bright orange/yellow flowers that adorn many Day of the Dead artworks. Their vibrant color and fragrant scent guide the deceased back home. During the celebrations, flowers are also representative of the fragility of life.

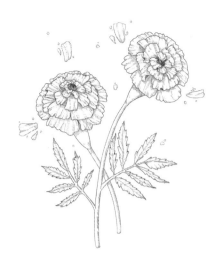

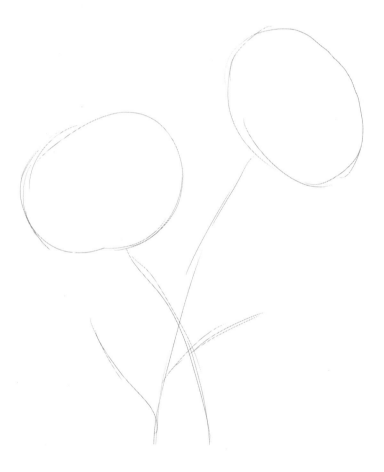

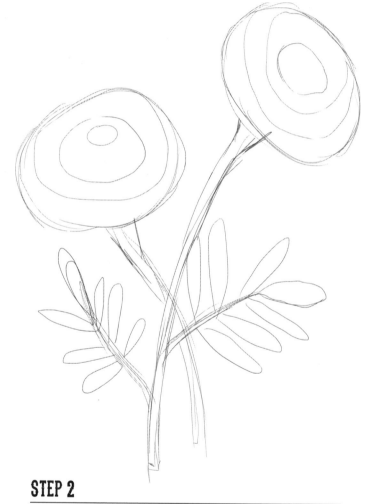

STEP 1

Before you start drawing, decide how many flowers you want to include in your illustration. Once you have decided, draw ellipse shapes where you want the heads of your flowers to be. These shapes don't have to be perfect and will be a guide as to where your petals will fit. Once you have your guides in place, you can add in lines for the stems. To keep your illustration interesting, try varying the height and size of your flowers.

STEP 2

Now that you have your basic guides in place, you can block in your shapes. The stems of the flowers will each be a cylindrical shape that bulges out where it joins the flower head. You can sketch out your leaves by drawing oval shapes along the stems on either side so that they are symmetrical, with one leaf coming out of the end of each stem. Draw inner circles on the inside of the flower heads as guidelines for positioning your petals.

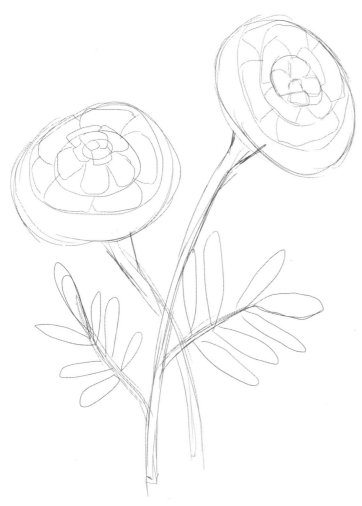

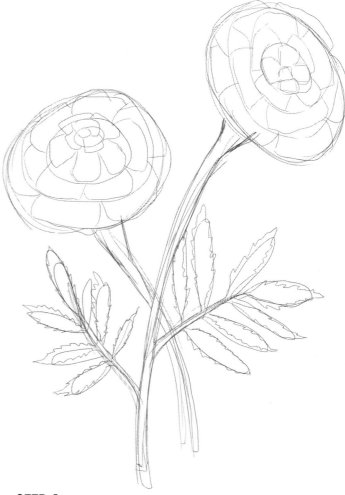

STEP 3

You should now have a complete under sketch of your flowers, stems, and leaves. Now start to shape your petals. Start in the middle with a swirl shape and work your way out. The bases of the petals will be narrower than the tops. Each line of petals will alternate with the last line, so that they don't start in
one spot.

STEP 4

Continue to add in your petals until you reach the outside guide circle. At this stage, you can start to add in more details to the leaves; they should have jagged edges. You can also start to erase some of your guidelines.

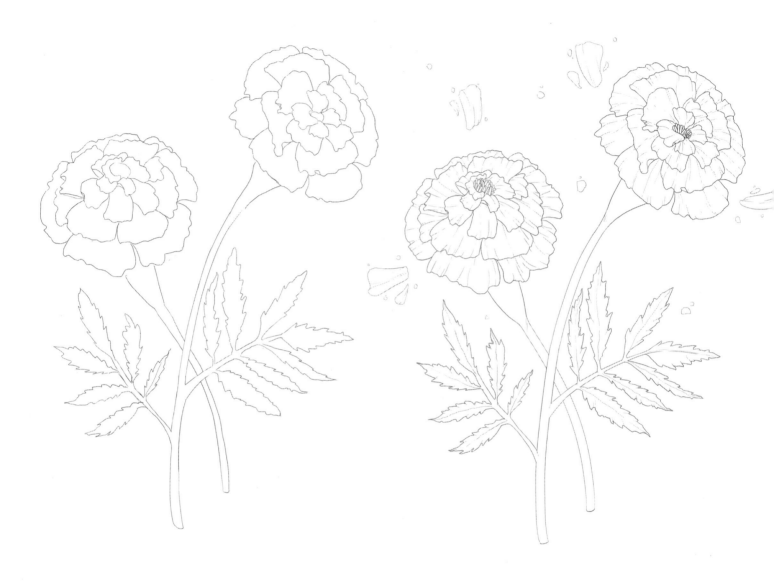

STEP 5

Now that you have your outlines complete, you can add in more details to the petals. They should have curvy, wiggly lines, and some of them will be bent back. Delete the remaining guidelines.

STEP 6

You can now start to render your illustration, making the outlines neat and tidy and adding in final details, such as the creases and folds in the petals and a line down the center of each leaf for the veins. You can add in any background elements you want or place your flowers in a scene. Use shading to bring out form (see the final image).

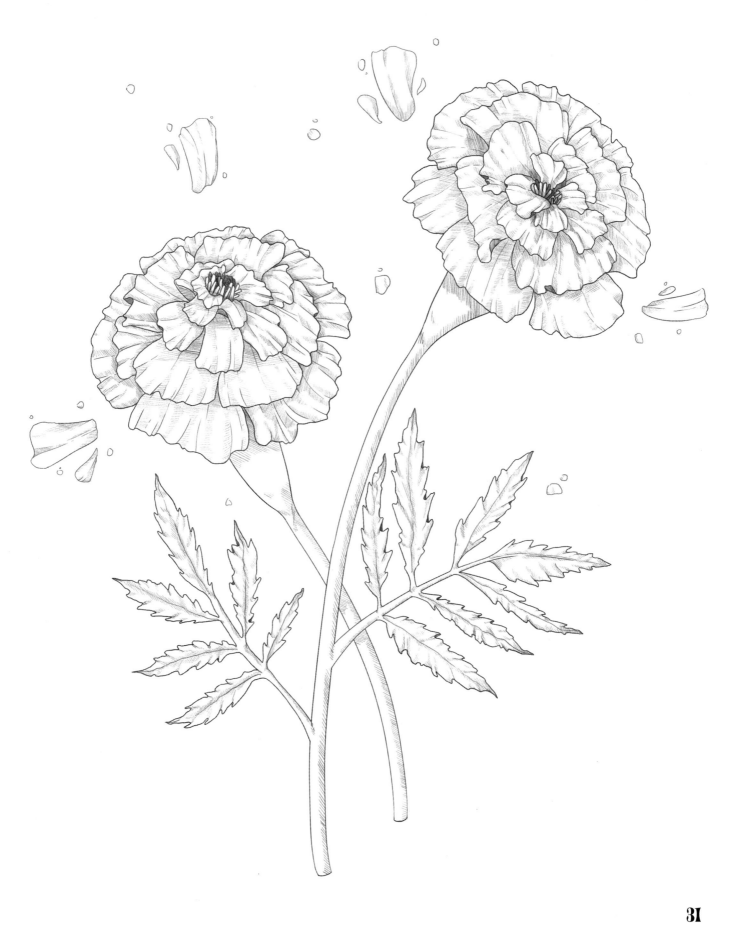

PAPEL PICADO

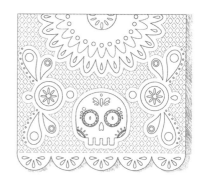

Papel picados or "perforated papers" are decorative pieces of paper cut into delicate and intricate patterns. They are often made from colored tissue paper and are used to decorate homes and streets during the celebration.

STEP 1

Start by drawing half of the outer edges of the *papel picado*. This shape can be square or rectangular and often has die-cut edges. Once you have the basic shape of your banner, draw a guideline down the middle, splitting the shape in half. Having a ruler on hand for this will be a big help.

STEP 2

Now that you have the base of your *papel picado,* you can start to customize it. It's easiest to start by adding some frills at the edges and working your way into the middle. Be aware of where your center guide is: at this stage you are only working on one side of the shape because the image will be flipped later on.

STEP 3

Once you are happy with the outline of your *papel picado*, you can begin to draw the inner design. Build this up using basic shapes and outlines at first, before adding all your details. This will help to make sure all the elements of your pattern will fit. The best way to form uniform circles is to use a compass or draw around something round, like a coin.

STEP 4

After you have mapped out where you want the details to go, you can start to fill in basic shapes with finer details. Circles, teardrops, skulls, and flower shapes work well here.

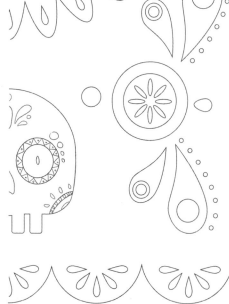

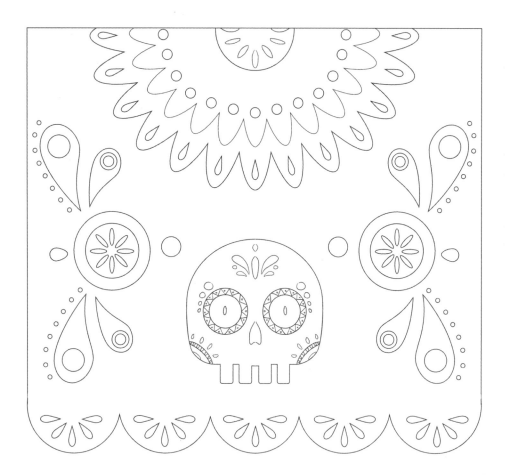

STEP 5

Once you are happy with the amount of detail you have, grab some tracing paper or parchment paper and trace over the half of the design you have completed. When you have traced over it all, flip the traced image over horizontally and line it up with the original half. Rub the back of the tracing to transfer the design onto the blank half. You might have to go over the transferred image again, as it will be lighter than the other side.

STEP 6

When the image is complete, you can add more details to the background if you want, or leave it how it is. You can even cut your design out! A little shading around the edges will add dimension (see the final image).

FRUITS

During the celebration, fruits are put out as offerings for the returned souls to enjoy when they visit home. The types of fruits and foods that are put out depend on what the person enjoyed when he or she was alive.

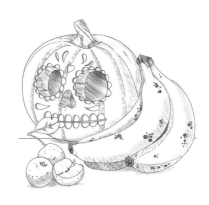

STEP 1

Decide which fruits you want to include in your image and then think about their basic shapes. It's always handy to start off with a baseline so all your objects are sitting on the same plane. Some fruits will have to sit in front of others and will therefore not sit on the baseline you put in; that's okay because of the perspective we are working with. It's more visually appealing to arrange the bigger fruits at the back so the smaller ones can be seen.

STEP 2

Start to block in the shapes of the fruits more clearly. Don't worry if you can see the guidelines from the fruits that are behind through the foreground fruits. Pumpkins can come in all shapes and sizes, but for this image I have used a nice plump, round one, which gives plenty of room to draw a carving on, later. Bananas are a fairly standard curved cylinder shape and the tejocotes are small and round.

STEP 3

When you are happy with the placement of your shapes, you can rub out the lines of the overlapping shapes, sending some fruits to the back of the composition and bringing others forward. When the fruit shapes have been rendered out a little more, start to add in some details, such as the stalks and leaves on the tejocotes and pumpkin, and the stems on the bananas.

STEP 4

Once the bigger details have been added, you can start to add some smaller, more intricate details. To make the fruits look more realistic and authentic, you can add spots, bumps, and blemishes to them. Not every fruit is perfect!

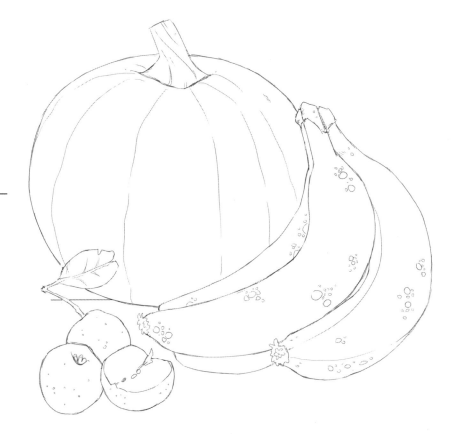

STEP 5

Once you have roughed up your fruit a little, you can begin to sketch out a pattern or a face onto your pumpkin. You can choose some of the patterns and elements we have used previously in this book. I have given this pumpkin a skull face to fit in with the Day of the Dead theme.

STEP 6

Make your carving three-dimensional by doubling up the lines to give the shapes an inner edge where you can see through to the inside of the pumpkin. The eyes and nose will have a thicker edge than shallower carvings, such as the teeth and the swirls. You can bring out this carved pumpkin drawing at your Halloween celebrations too! Complete the effect with some shading (see the final image).

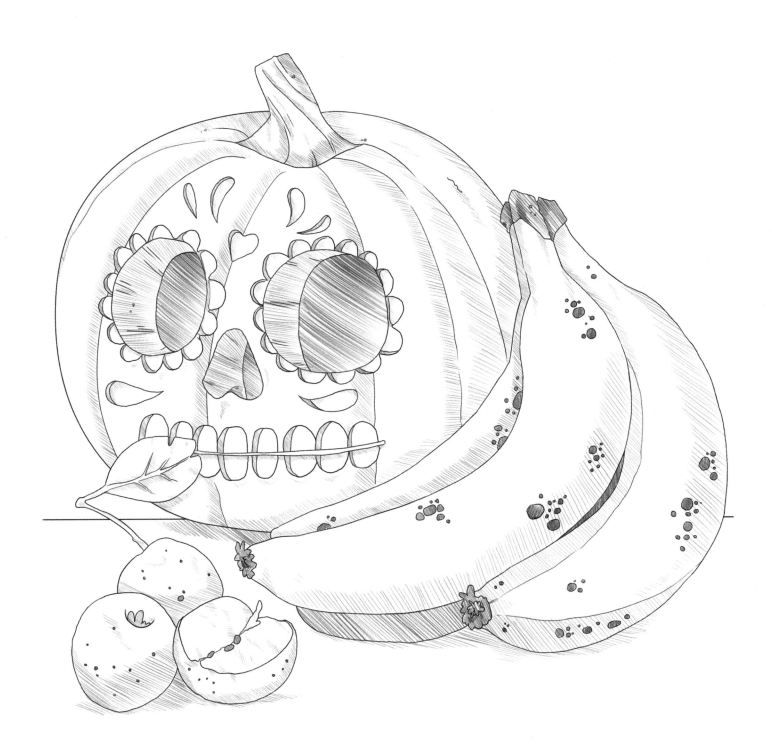

CANDLES

The burning light of a candle and the scent of incense are used as beacons for the returning souls to find their way back home.

STEP 1

Start by drawing a baseline for your candles to sit on. Having a baseline will help with perspective and make sure that your candles look like they are sitting together. Place some ovals where you would like the tops of your candles to reach. Make them as wide as you would like your candles to be.

STEP 2

Draw more ovals with the same width as the top ovals where you would like the bottom of your candles to be. Be aware of where your baseline is. The bottom ovals will sit over the baseline, which is fine because of the perspective of your image.

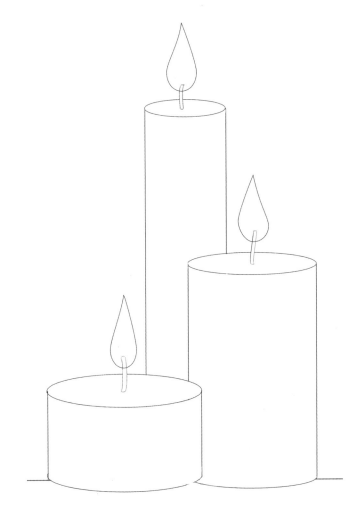

STEP 3

Now you can arrange your candles. Decide which one you want at the front and erase the lines of the background candles. Move on to the next candle and repeat. Once you have done this, you will be ready to add detail to your outlines.

STEP 4

The first details you can add are the wicks and flames. You will be able to see the wicks through the flames. The flames are brightest at the top and darkest toward the wick.

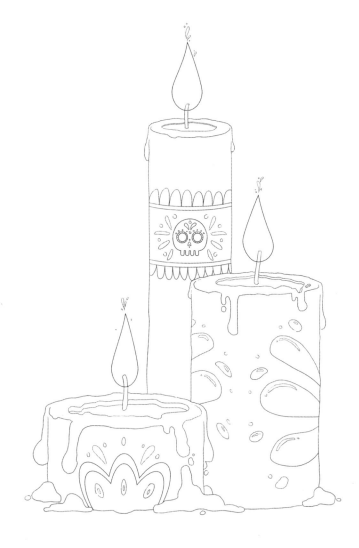

STEP 5

Now you can start sketching in some melted wax. These shapes will be smooth and rounded. In the drips running down the sides of the candles, the bottom of each drop will be larger and heavier due to gravity and the build-up of wax. Some of the melted wax will pool around the bottoms of the candles and drop down onto the base. Some candles can have melted more than others.

STEP 6

Add in some final decorative shapes, such as teardrops, petals, and skulls, to make the candles more festive. A little shading now will make the candles more three-dimensional and help to ground them (see the final image).

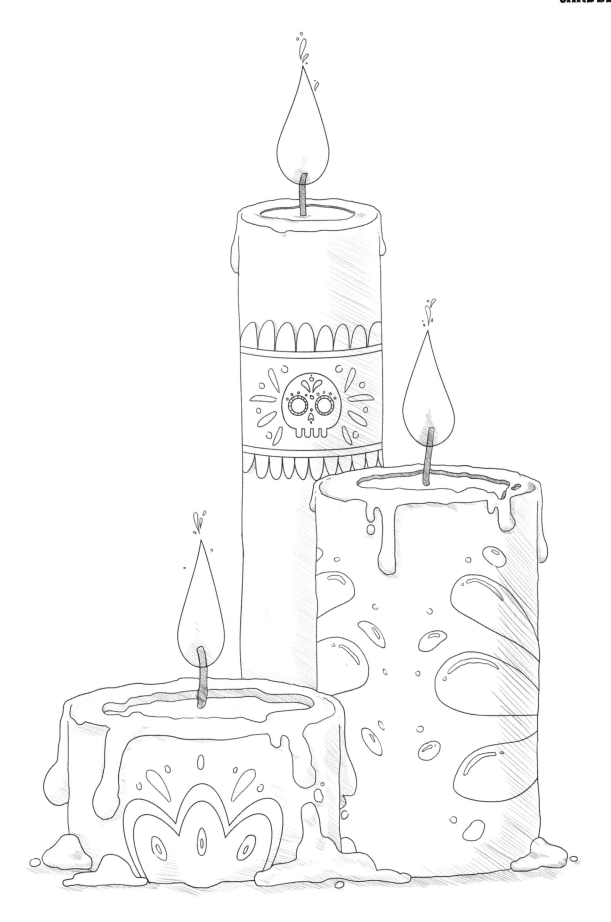

ALTAR

Altars or *ofrenda* are an important part of the Day of the Dead celebrations, honoring a family member, a loved one, or any special person. Altars are comprised of different tiers and each object placed on it has a special meaning, which helps to guide a spirit through their journey home. Altars are often decorated with *papel picados*, candles, photos, flowers, and food and drink.

STEP 1

Day of the Dead altars come in many different shapes and sizes, but for this example I will show you how to build up a two-tier one, using some of the elements we have drawn in the book so far. This will be a good exercise in perspective, as well as drawing more complex scenes. As always, start by drawing a baseline guide.

STEP 2

Now you can build the bottom tier of your altar. It will be easier to get an even shape if you use a ruler at this stage. To start, draw the right-hand side of your altar as a skewed rectangle shape. Draw this shape as high and deep as you want your altar to be. Draw another rectangle, at the same angle, for the left-hand side, the same size as the other. This will be the left-hand side of your altar. Now connect the corners of these rectangles with straight, vertical lines.

STEP 3

Follow the instructions in step 2 to make your top tier. This will be smaller than your base tier, but the shape you make is up to you. Once you have the top tier in place, you can erase the lines that will not be seen behind the front planes of the shapes.

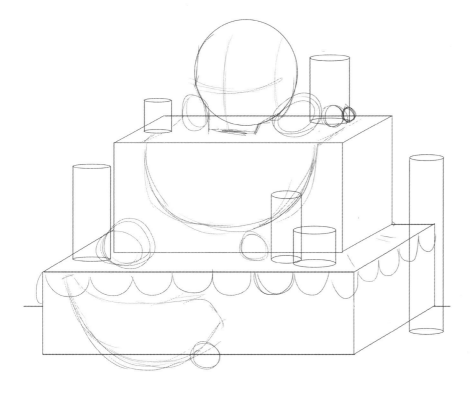

STEP 4

Now that you have a solid base, you can decide what you want to include on your altar. I will include a skull, marigolds, candles, bananas, and tejocotes. You can include any of these items and much, much more! Start to draw in the basic shapes of your items where you would like them to be, using the methods you have previously learnt.

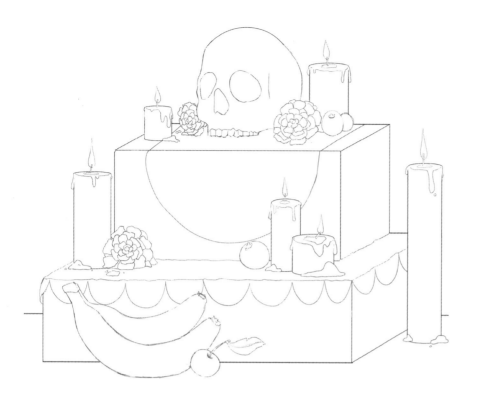

STEP 5

Once you have your outlines in place, you can erase the lines showing through your shapes and start to block in some of the bigger details, such as the features on the skull, the melting drips of candle wax, and the designs on the *papel picados*. The level of detail included in each of these elements is completely up to you, but to avoid a very busy-looking illustration, you might want to keep them simple.

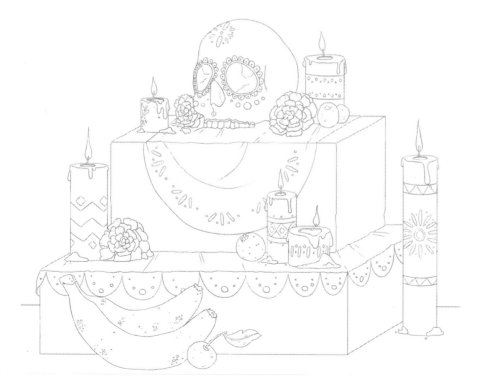

STEP 6

Add in the final details and any other background elements you want to include (see the final image).

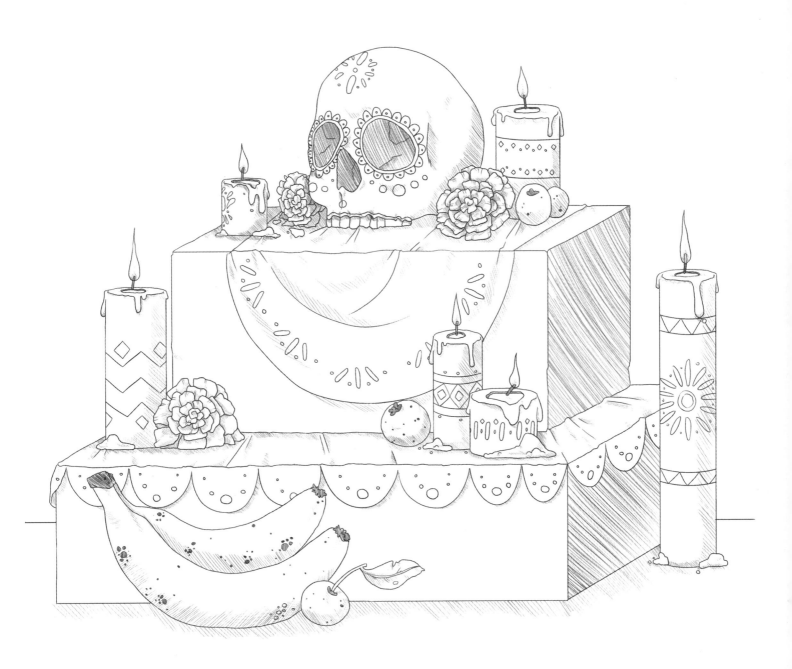

MONARCH BUTTERFLIES

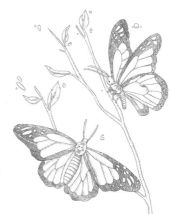

Monarch butterflies migrate to Mexico every fall around the time of the Day of the Dead festival and were believed to be the spirits and souls of loved ones returning home.

STEP 1

The first step with this artwork is to decide how many butterflies you want to include and where each one will sit. Draw in a baseline or any lines for branches.

STEP 2

You can start drawing your butterflies by laying down some guidelines for where you will place them. You can either have them flying or landed. To build up a butterfly, start by drawing an oval for the thorax, a thinner, longer oval for the abdomen, and smaller circle for the head.

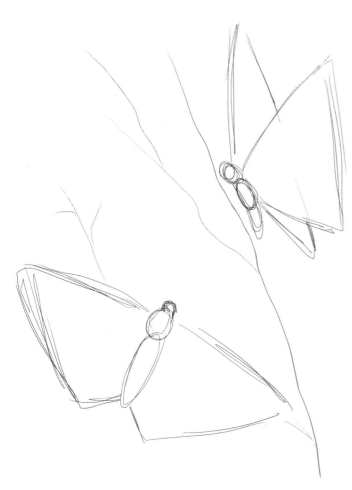

STEP 3

Once you have the bodies in place, you can sketch out the butterflies' wings using basic triangular shapes. Each triangle will have a different angle, depending on the way in which the butterfly is facing.

STEP 4

With most butterfly wings, the large triangle shape is broken down into smaller triangles. With the monarch butterfly, the wings can be broken down into two smaller triangles, connected to the body of the butterfly.

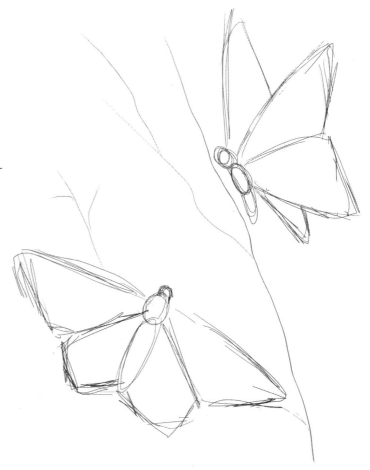

STEP 5

Once you have your base triangles in place, start erasing your guidelines and rounding out the corners to make them softer.

STEP 6

At this point, you can build up any background elements you want to include and add in the final butterfly details like the legs, body fur, and antennae. For example, in the background, you could include flowers, leaves, and twigs, or if you want to include more Day of the Dead elements in your illustration, you could draw your butterfly on a skull or a gravestone (see pages 84–87 for an example).

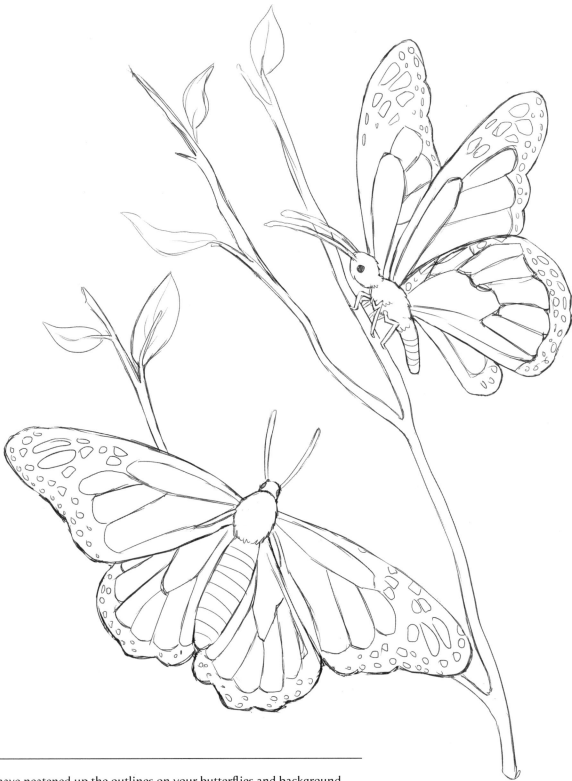

STEP 7

Once you have neatened up the outlines on your butterflies and background elements, you can start to fill in the pattern on the butterflies' wings. The easiest way to do this is to grab a reference from the Internet, a book, or if you're lucky enough, a live butterfly, and study the markings that you see. The basic shapes the pattern is made up from are geometric. There tends to be a longer shape at the top of the wing with smaller shapes branching out. The shapes get smaller and more intricate the further away from the butterflies' bodies that you get.

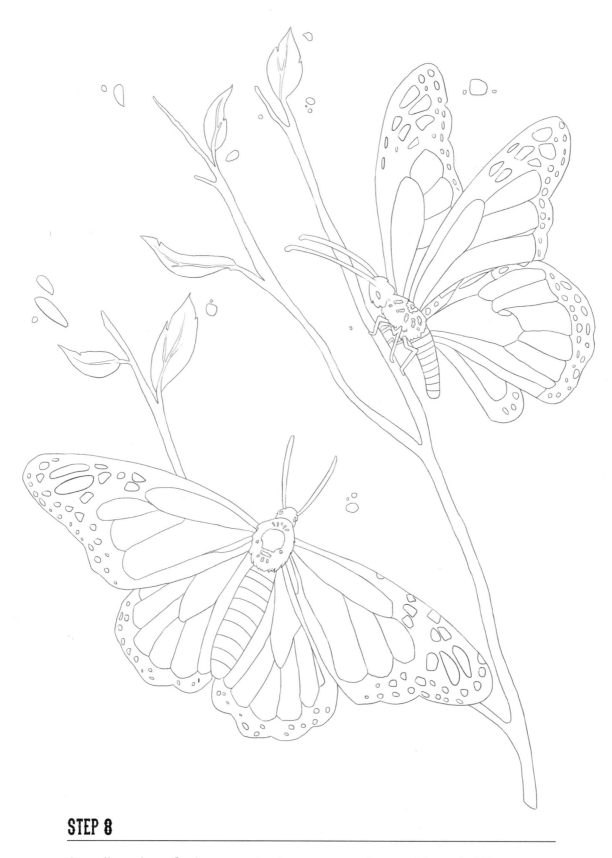

STEP 8

Once all your butterfly elements are in place, you can render everything and add in any extra details you may have missed or any ideas you have had later on. Shading completes the effect (see final image).

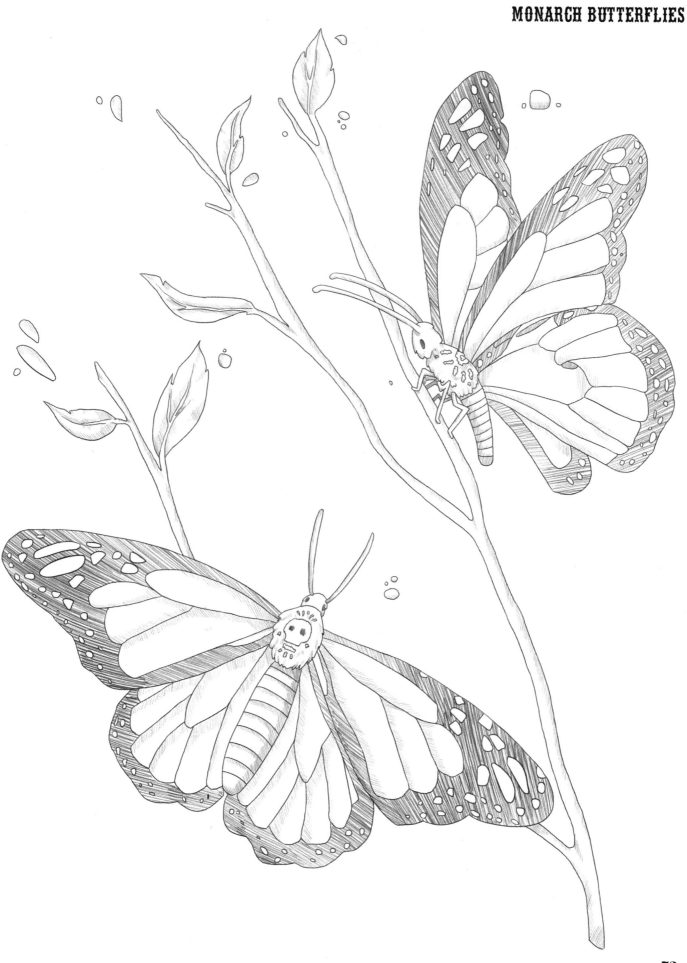

PORTRAIT OF A LOVED ONE

A portrait of the person you are honoring is placed on an altar or around the home as a sign of remembrance.

STEP 1

To start this illustration, draw a rectangle as a guide for where you would like the inside of your frame to go. This will give you a space to work in.

STEP 2

Once you have drawn your rectangle, you can draw a circle as a guideline for the head. The head will turn out a little bigger than the circle guideline, so make sure you leave enough space between your circle and the frame, but it's okay if some elements get cut off. Having a reference picture of your subject will make this a lot easier.

STEP 3

For this example, I will show you how to draw a three-quarter view of a face. You may find this more difficult than a front-facing view because of the perspective involved. Draw a curved line on the circle, on which you want the nose to center. Extend that line about half the length of the circle past the bottom of it and mark the other two thirds evenly along it. Now draw another curved line, roughly where you think a third of the circle would be from the center line.

STEP 4

Now you have these basic guidelines, you can work out where to put the facial features. The bottom of the nose should end just above the third horizontal line and the eyebrows should start just below the second horizontal line. The eyes will sit just under the eyebrows. The distance between the eyes will be shorter due to the perspective and the eye furthest away from you will be smaller than the other. The lips will be about three-quarters of the way up, between the third and fourth horizontal lines, just below the nose. The top of the ear should be close to the brow line, about halfway between the second curved line and your base circle.

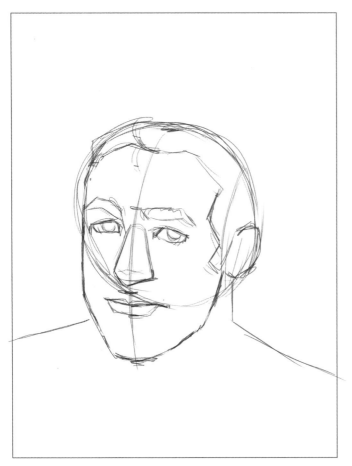

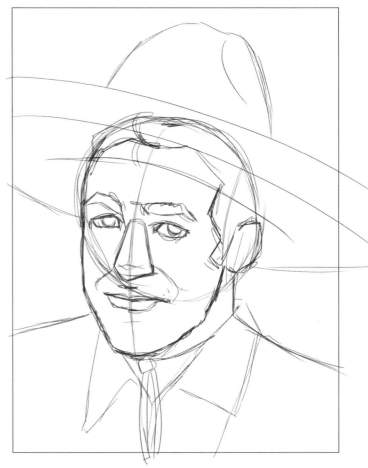

STEP 5

Now you have all your guides in place, you can begin to block in the facial features. The basic shape of the nose is a triangle and each eye will be like a squashed rectangle. The lips are made mainly from triangles, as are the ears. The hairline follows the top of the forehead and finishes up close to the ears. The jawline descends below the base circle and culminates at the chin which is formed at the fourth horizontal line. The ear will form inside the base the circle and the side of the neck extends down, horizontally, from behind the ear.

STEP 6

From here, you can start to add in clothing and any background elements you want to include, remembering that clothing will bunch, fold, and move with gravity. Also begin adding in facial details, such as creases and lines.

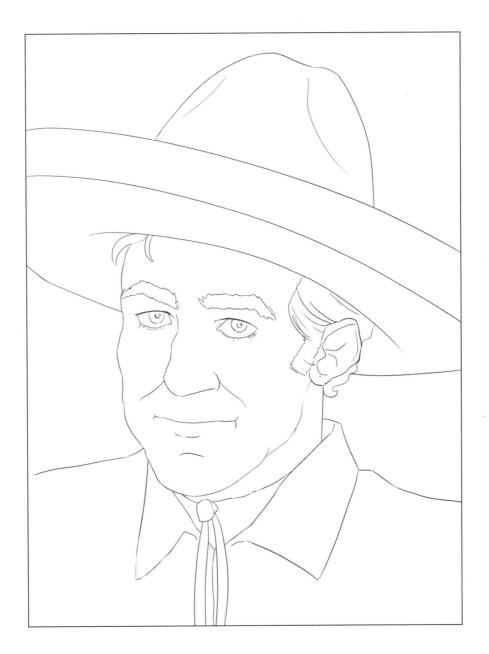

STEP 7

Once you have sketched out the basic face shapes, you can erase your guidelines
to start to render your image, smoothing any sharp angles and adding any distinct
features your subject has.

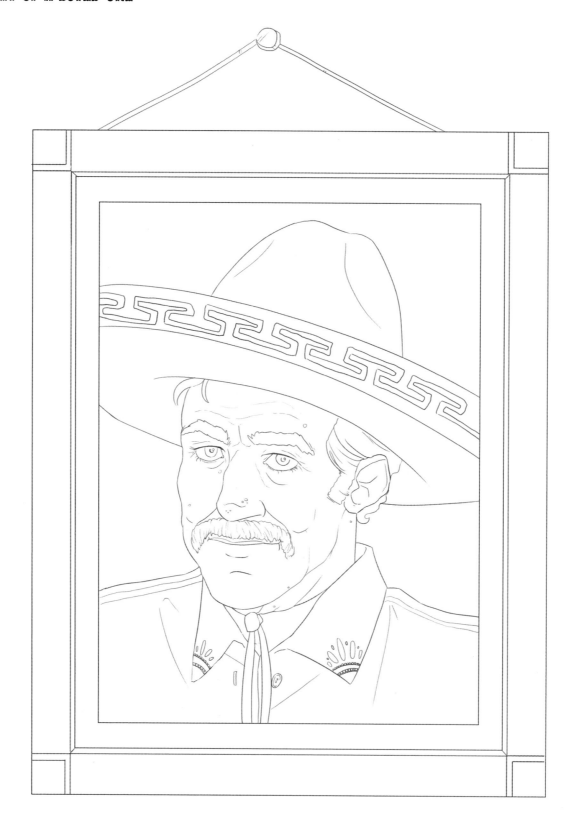

STEP 8

Once you are happy with how your illustration is looking, you can add in any final details such as smaller wrinkles, facial hair, and moles, and build up your frame using any decorations you want.

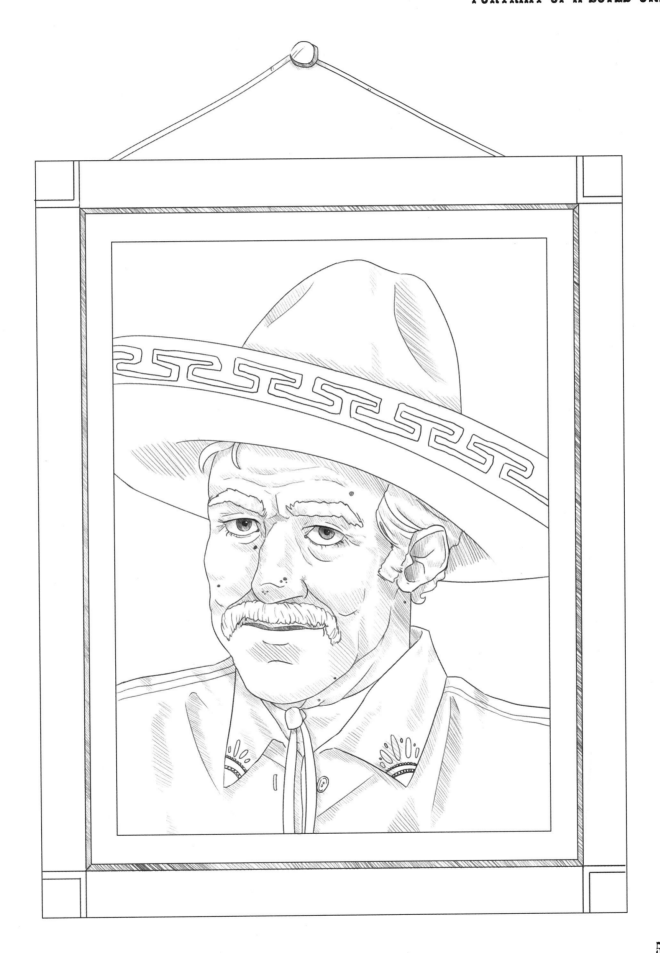

GIRL IN COSTUME

During the Day of the Dead celebration, there are many lively parades. People dress in traditional clothing and paint their faces, often carrying flower baskets and other objects on their heads, while performing and dancing in front of the crowd.

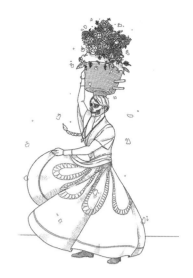

STEP 1

To begin drawing your girl, as with many of the drawings, put down a baseline. Once your baseline is in place, the next line you add will be a movement line, to get the flow of how she is moving. Try to draw this line in one quick movement around where you want her spine to be positioned. Next, add in horizontal lines where her shoulders and hips will go, and a circle for her head.

STEP 2

From there, you can go in and block out her rib cage, hips, and head (see step 2, page 20).

STEP 3

When these shapes are in place, add circles on top of them where her shoulder and hip sockets will be, so you can map out the arms and legs. Once you have worked out where you want the arms and legs to start, you can add in lines going in the basic directions you want the limbs to be. Try to keep these lines loose so your figure doesn't look stiff.

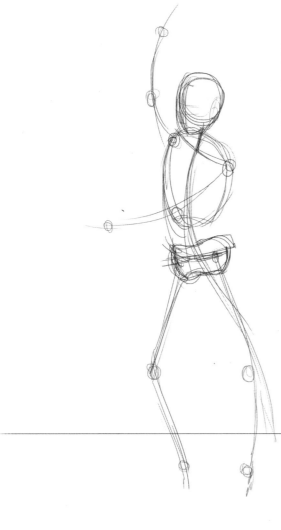

STEP 4

When you are happy with your guidelines, add in circles for the other joints like the elbows, wrists, knees, and ankles. At this stage, you can also add in the guidelines for the face (see page 55).

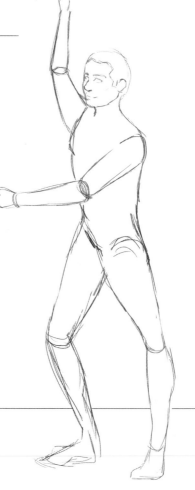

STEP 5

Now you can block in the body shapes, using cylinder shapes for the arms and legs and triangles for the hands and feet. Connect the rib cage to the hips and the head to the body. Once you have done this, you can erase any guidelines showing through your girl. You can also start to add in her facial features.

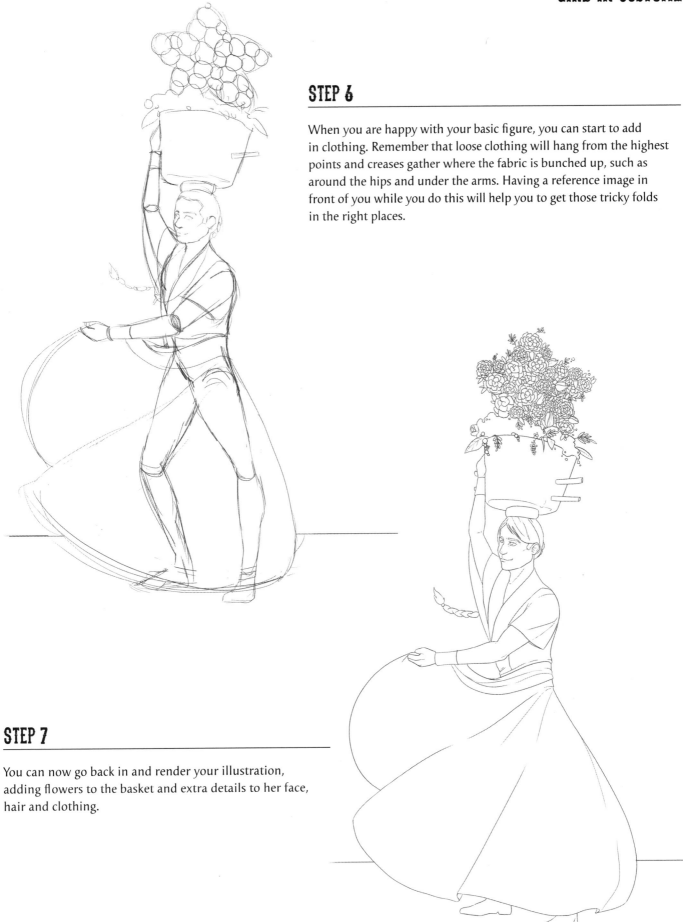

STEP 6

When you are happy with your basic figure, you can start to add in clothing. Remember that loose clothing will hang from the highest points and creases gather where the fabric is bunched up, such as around the hips and under the arms. Having a reference image in front of you while you do this will help you to get those tricky folds in the right places.

STEP 7

You can now go back in and render your illustration, adding flowers to the basket and extra details to her face, hair and clothing.

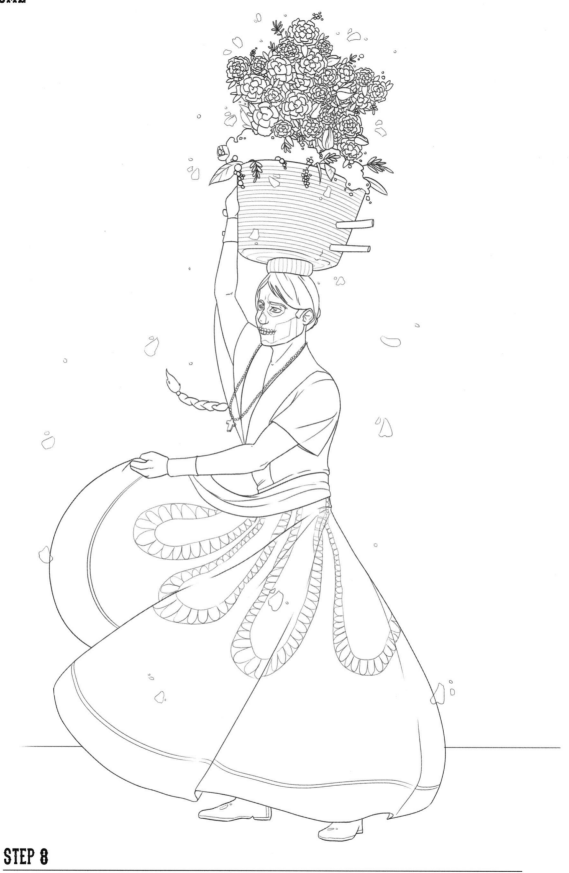

STEP 8

Finish adding details such as the basket weave, flower petals, and, of course, her sugar skull makeup! Add in any background elements, if you wish as well as shading (see the final image).

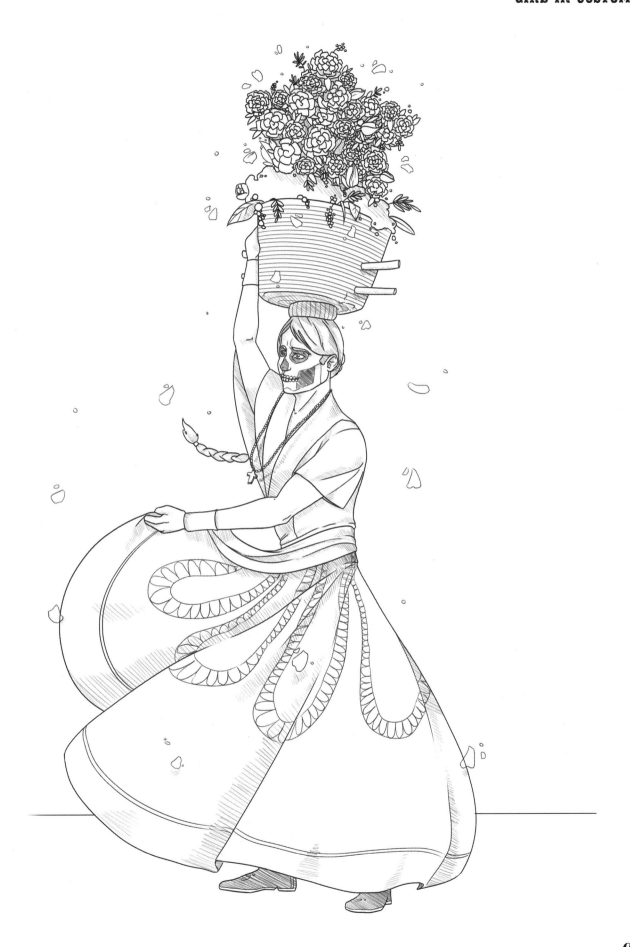

SKELETON DOG AND CAT

Like people, animals can be dressed in costumes or painted to join in with the celebrations. Dogs were believed to guide the souls of the deceased to the underworld.

STEP 1

As with the previous illustrations, start by drawing a baseline for your animals to sit or stand on. You can now decide what type of dog and cat you want to draw. Different breeds can vary greatly in shape and size, so it's good to have an idea of what they look like before you start. When you have decided, sketch some movement lines where you would like to place your animals.

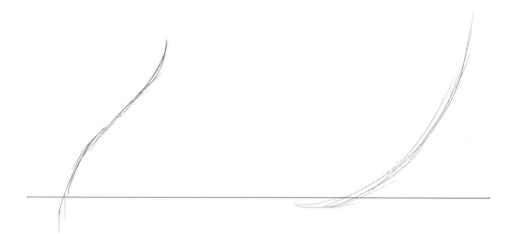

STEP 2

Next add in guidelines for the hips, shoulders, and heads.

STEP 3

Now you have your movement lines in place, sketch some basic guideline shapes over the top as shown. Add facial guides to the animals' heads, an oval shape for their chests, and a smaller circle for their hips (as showns).

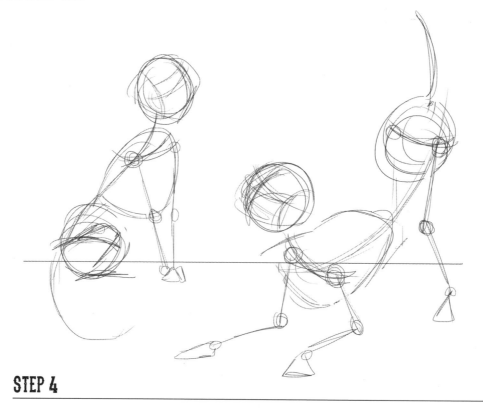

STEP 4

At this stage, you can add in some lines for the legs and tails, triangles for the paws, and small circles for the joints.

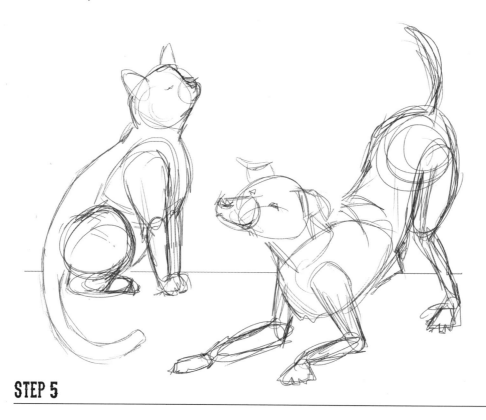

STEP 5

Now you have your guidelines in place, you can give your animals form by blocking in the shapes of the legs and tails. You can also add the snouts and ears, as well as the animals' facial features. Start to delete some of the guidelines..

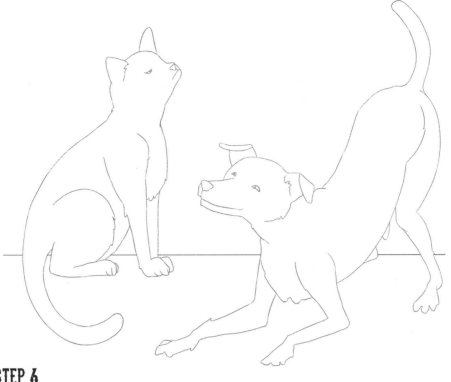

STEP 6

Once you have completed the base of your animals, you can erase the remaining guidelines while you render the outlines and start to add more detail.

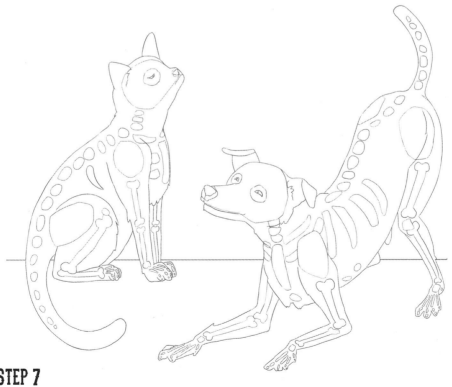

STEP 7

You can either have your Day of the Dead animals dressed up or painted as skeletons. The animals in this example have been drawn with their skeletons painted on. To do this, start to draw the skeleton over the top of your sketch; a reference image will help you. Add in any other details such as fur, or even some clothing, if you like.

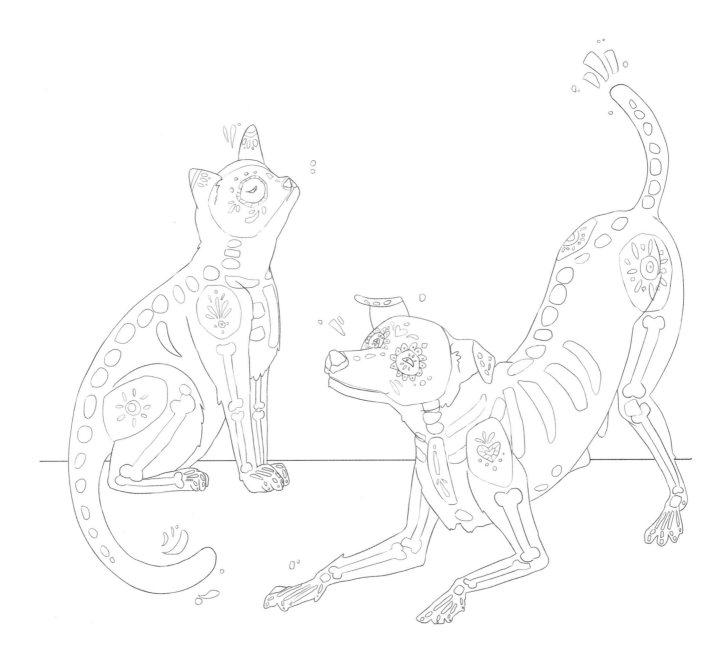

STEP 8

Now you can finish rendering your illustration and add in any background elements, if desired. Shading is the finishing touch (see the final image).

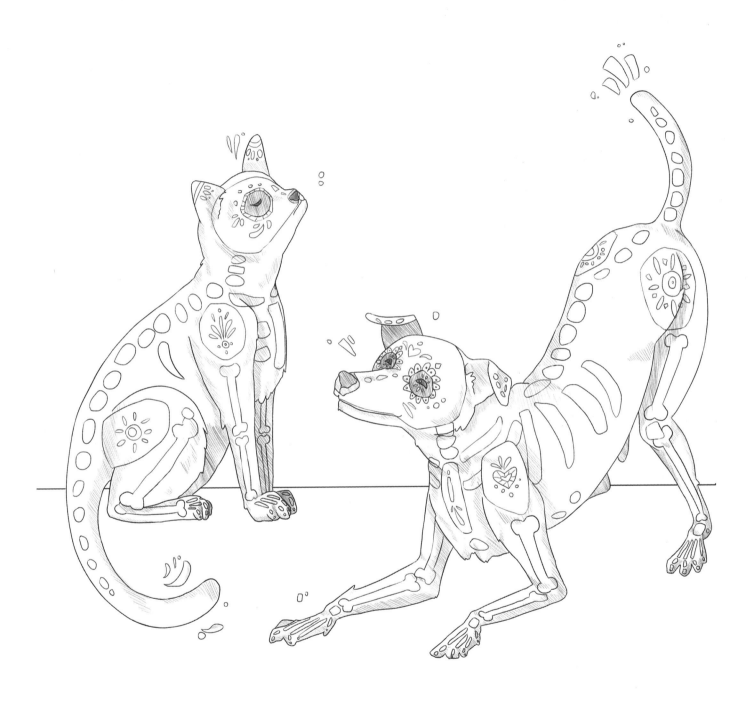

SKELETON IN PONCHO RELAXING

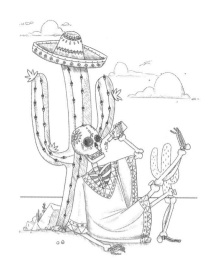

Cacti are a famous part of the Mexican landscape and are depicted in many artworks. Tequila, which the skeleton is drinking, is often left as an offering to spirits returning home.

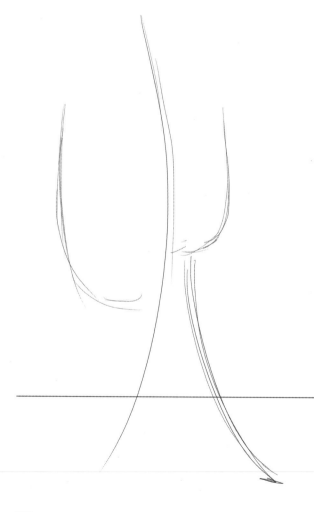

STEP 1

Begin by drawing a baseline for your scene. Once this is in place, you can draw in some movement lines and guidelines for where you want to place your elements. Giving your cactus a slight curve will help it to look more dynamic. To make your image more interesting, try adding the skeleton's movement line in the opposite direction.

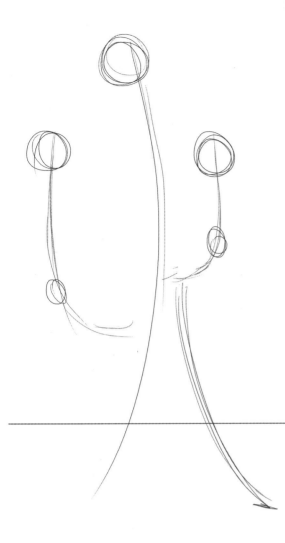

STEP 2

When you are happy with your guidelines, you can block in some basic shapes. Cacti come in many shapes and sizes, but for this example I will be teaching you the most recognizable cactus form, which consists of rectangular and circular shapes. Draw a circle where you want the top of your cactus to be and add other circles to mark the tops of the cactus arms. Draw in slightly smaller circles where you want the "elbows" for your cactus arms to be.

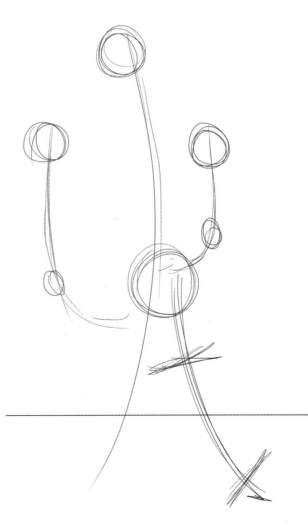

STEP 3

Once you know where you want to place your cactus, you can begin on the skeleton. As with the other figures in this book, start by adding in lines for the hips and shoulders and a circle for the head.

STEP 4

Sketch in the guidelines for the face and block in the skeleton's rib cage and hips. When you have these in place, you can add in lines for the arms and legs and small circles where you want the joints to be. Now draw any props you want your skeleton to interact with – in this case, the bottle of tequila.

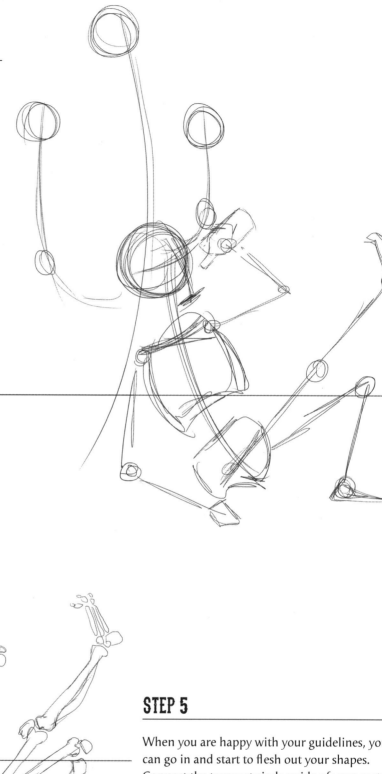

STEP 5

When you are happy with your guidelines, you can go in and start to flesh out your shapes. Connect the topmost circle guide of your cactus to the base, then connect the tops of the arms to the elbows and the elbows to the body of the cactus. Now you can build up your skeleton using a similar method to the Catrina and Catrín illustrations (see pages 20–27). Start to erase some of your guidelines.

STEP 6

Now you can add in the details of the clothing. Loose clothing, such as ponchos, will hang down from a point due to gravity, with creases tending to be toward the bottom and gathers occurring where the fabric bunches up.

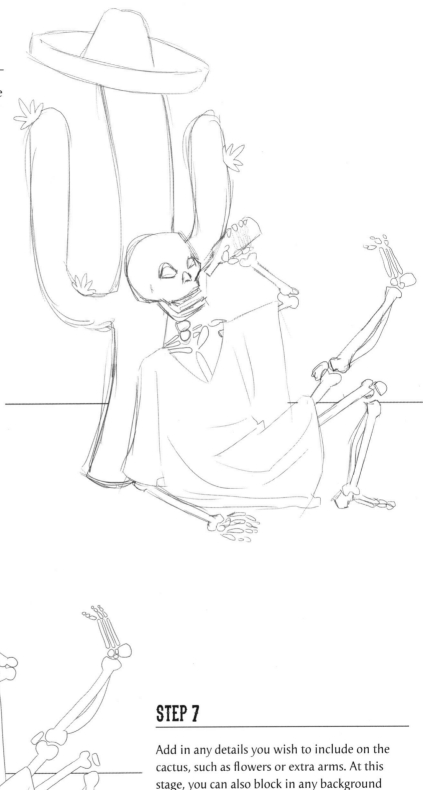

STEP 7

Add in any details you wish to include on the cactus, such as flowers or extra arms. At this stage, you can also block in any background objects you want to include and erase any lines showing through those elements.

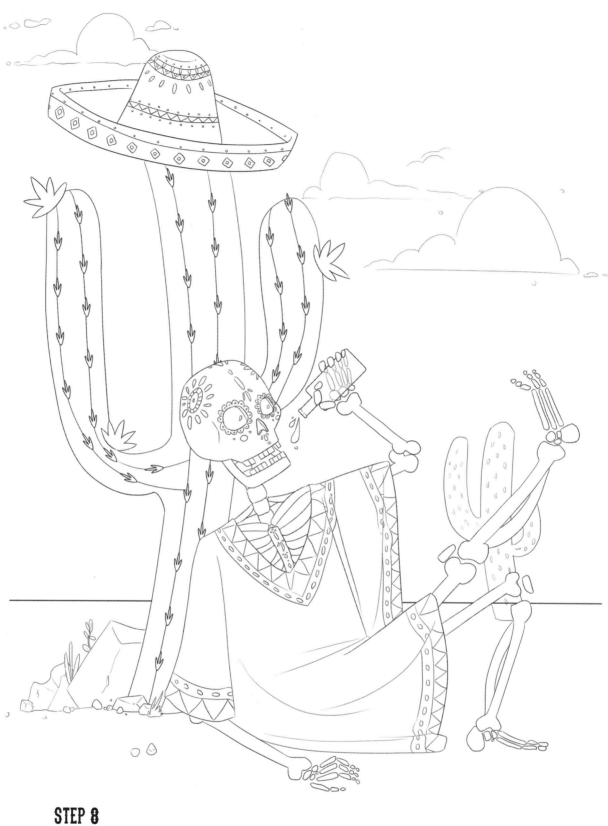

STEP 8

Once you are happy with your composition, you can render the image and add in any final details to the skeleton and cactus, as well as any other background elements you want to include. Add shading to make the cactus, sombrero and skeleton three-dimensional (see the finished image).

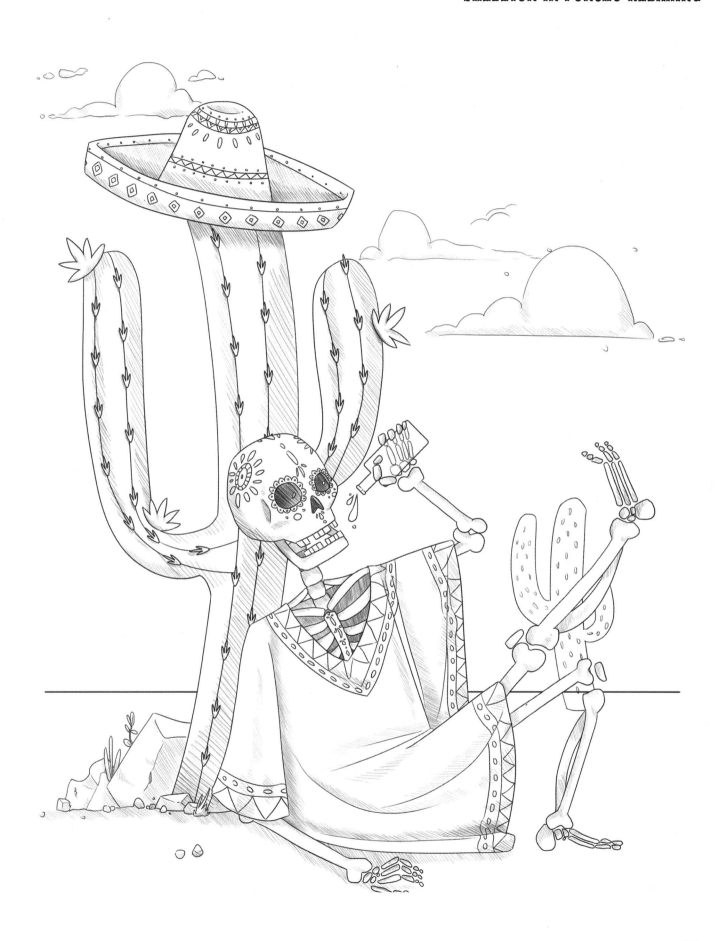

DANCING SKELETONS

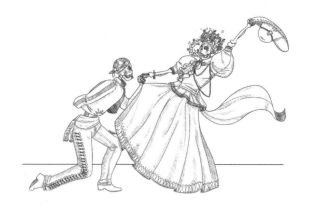

Singing, dancing, and having a good time are all part of the Day of the Dead celebrations. There are many types of dances performed, with each city or region having its own traditions, clothing, and techniques.

STEP 1

This image will be similar to the Girl in Costume illustration (see pages 60–65), but the difficulty level will increase here, as we have two figures dancing with each other instead of one. The image will start in the usual way, by drawing in a baseline and movement lines to get a feel for how the characters will interact.

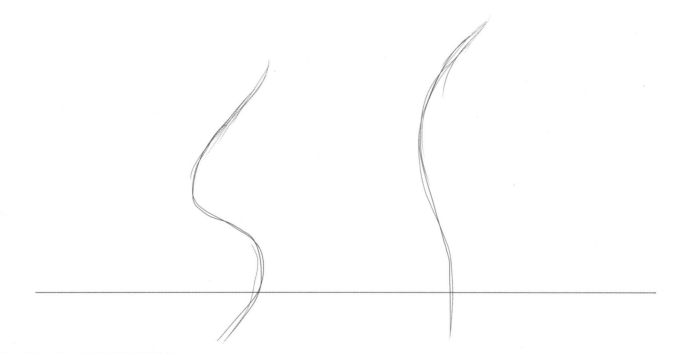

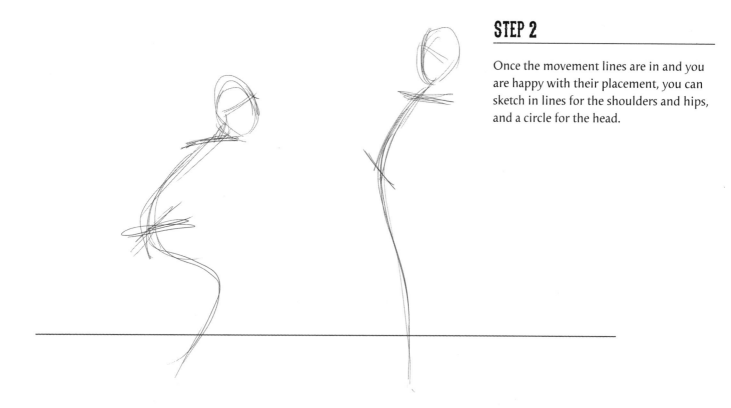

STEP 2

Once the movement lines are in and you are happy with their placement, you can sketch in lines for the shoulders and hips, and a circle for the head.

STEP 3

Once you have drawn your guides you can work out the movement of the arms and legs. A reference image will help you to get your characters' feet in the right places! Draw movement lines for the arms and the legs. Now add in circles for the joints and block out the hips and ribs.

STEP 4

When you have your basic "wireframe", you can block in the characters and start to draw the bones of your skeletons. Most of these lines will be covered by clothing, so it's up to you how much detail you want to put in to them at this stage. Connect the limbs to the torso and ribs. As these figures are skeletons, their ribs and hips will connect via their spines.

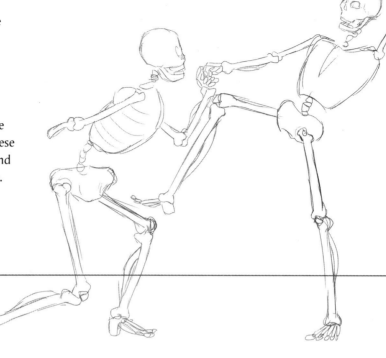

STEP 5

Now that you have blocked in your shapes, you can erase your guidelines and start to add in the guidelines for the clothing. There will be a decent amount of movement in this illustration, so the clothes will come off the figures more. Block the clothing in based on the direction in which your figures are moving.

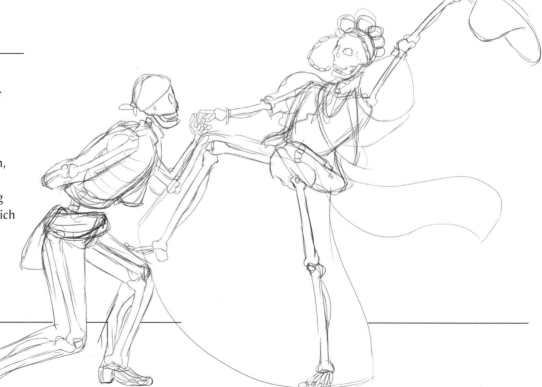

STEP 6

Once you have your basic clothing shapes, you can erase what won't show through. At this stage, you can add in the creases to your clothing. Remember that clothing will hang down from points due to gravity and creases will follow the movement, gathering where the fabric bunches up.

STEP 7

At this stage, you can go in and render the image, cleaning up your lines and adding in any extra details such as flowers and plaits in the hair.

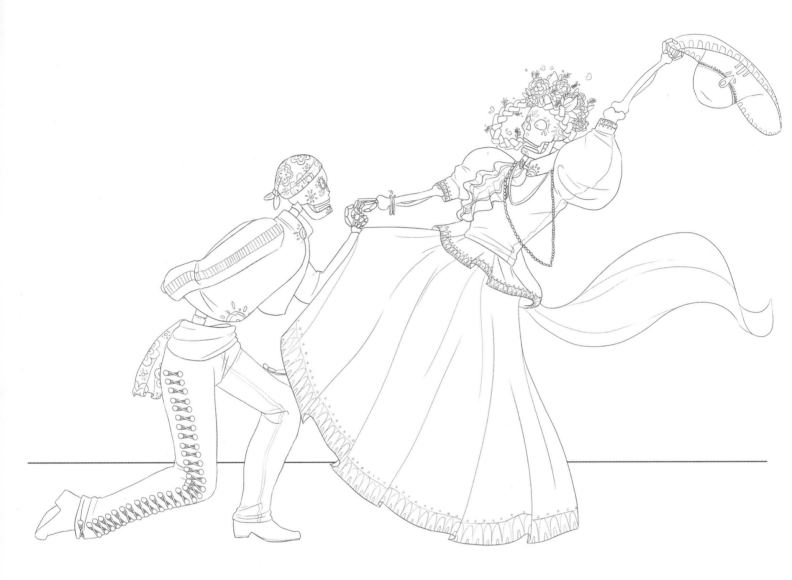

STEP 8

The final details can be added in now, such as clothing embellishments, and any background elements you would like to include. Complete the look with some gentle shading (see the final image).

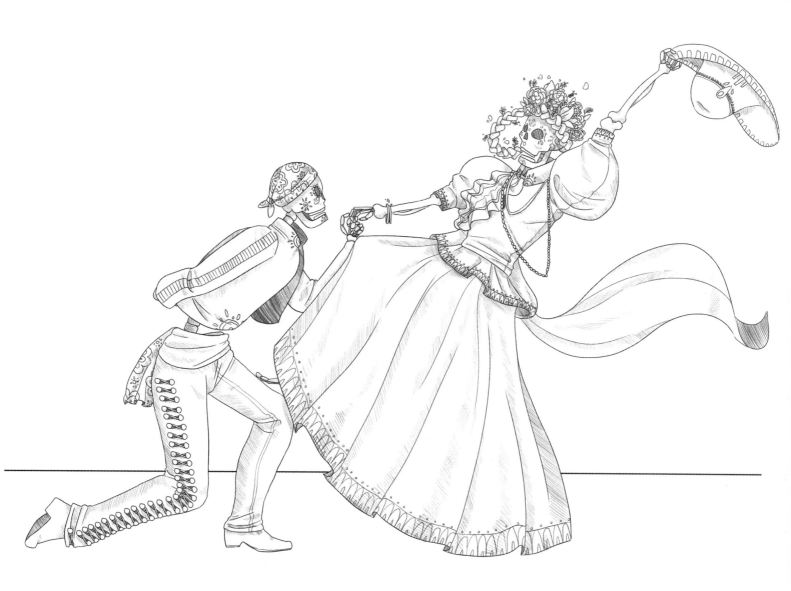

SUGAR SKULL, FLOWERS, AND BUTTERFLIES

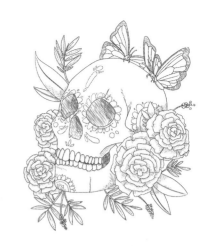

Skulls, butterflies, and marigolds are objects most people visualize when they think of the Day of the Dead festival. Here, they come together to create a striking image, which celebrates the beauty and fragility of life.

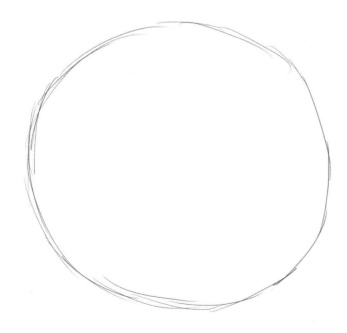

STEP 1

For this example, I will be using a three-quarter-view skull, which has the same basic shapes and guidelines as the Portrait of a Loved One illustration (see pages 54–59), with the exception of the facial features. To start, draw a rough circle.

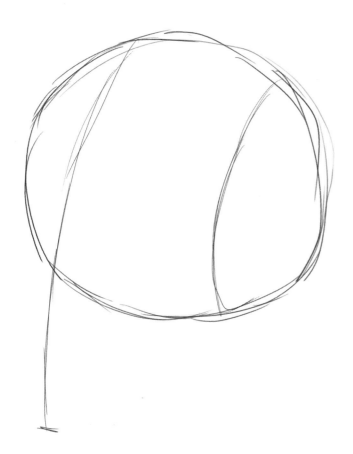

STEP 2

Draw a line running vertically through the circle where you want the nose cavity to be, extending past the bottom by about half the diameter of the circle. Add another curved line roughly where you think a third of the circle would be from the center line.

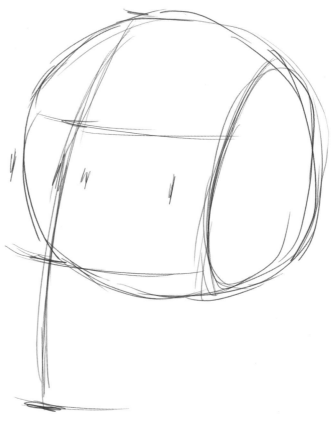

STEP 3

Now you can add in your horizontal lines, which will break your vertical lines into equal thirds. The bottom of the nose will sit just above the third horizontal line and the eye sockets will start just below the second horizontal line. The teeth will join about halfway between the third horizontal line and the chin line.

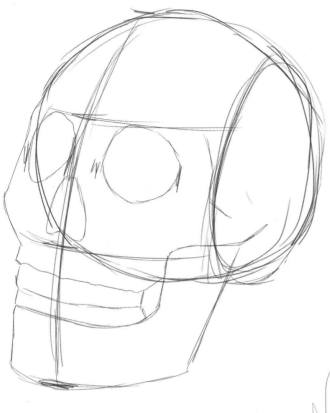

STEP 4

Now that you have your base, you can block in the jawline and sketch out where the eye sockets and nose will go, as well as adding in a guide for the top jaw and teeth.

STEP 5

At this stage, you can plan where to place any flowers and butterflies, or anything else you wish to add into your illustration. Erase your original guidelines and add in new ones for your flowers and butterflies. If you're stuck for ideas, you can always add the flowers just around the base of the skull, or arrange them around the top like a flower crown. You could even put something in the skull's mouth!

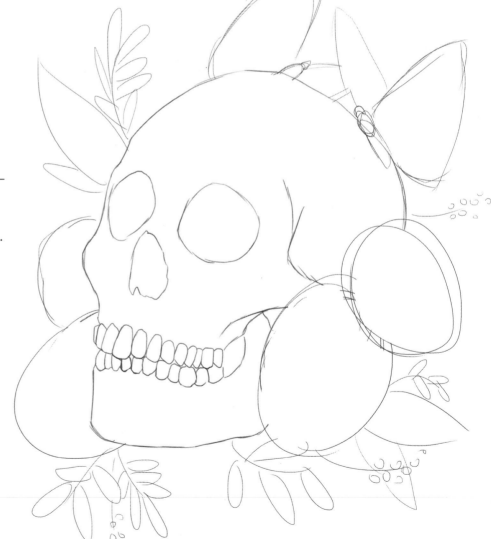

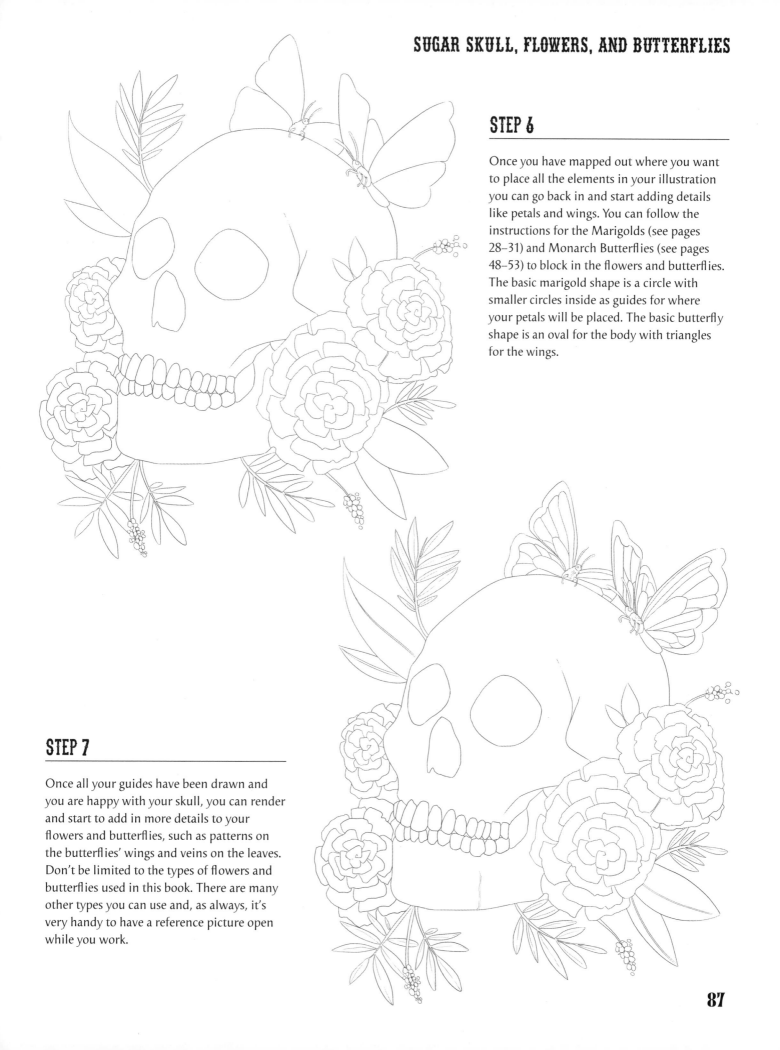

STEP 6

Once you have mapped out where you want to place all the elements in your illustration you can go back in and start adding details like petals and wings. You can follow the instructions for the Marigolds (see pages 28–31) and Monarch Butterflies (see pages 48–53) to block in the flowers and butterflies. The basic marigold shape is a circle with smaller circles inside as guides for where your petals will be placed. The basic butterfly shape is an oval for the body with triangles for the wings.

STEP 7

Once all your guides have been drawn and you are happy with your skull, you can render and start to add in more details to your flowers and butterflies, such as patterns on the butterflies' wings and veins on the leaves. Don't be limited to the types of flowers and butterflies used in this book. There are many other types you can use and, as always, it's very handy to have a reference picture open while you work.

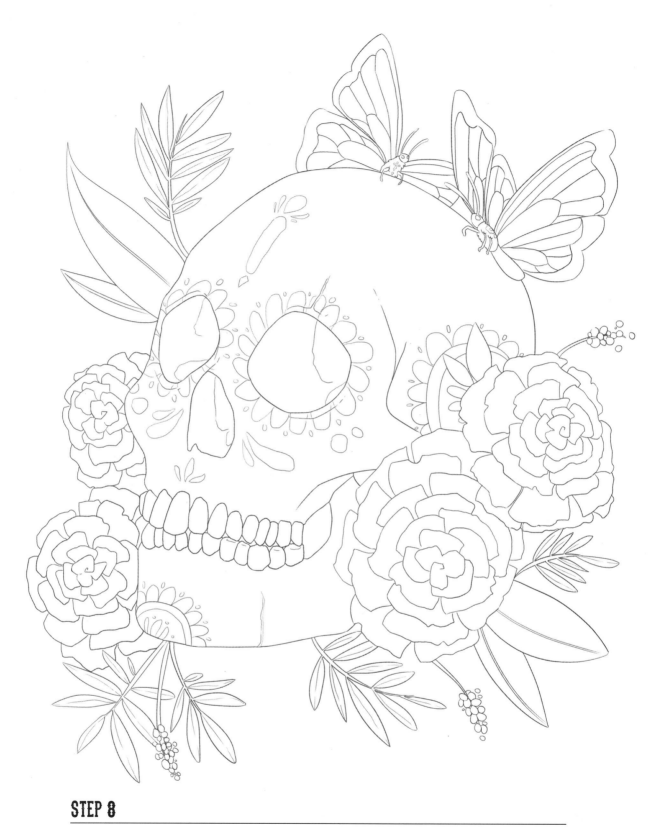

STEP 8

This is the time to add the final details and erase any stray or unnecessary lines. To make this illustration more festive, you can add in Day of the Dead sugar skull decorations to your skull and any other background elements you want to include. Add shading to finish (see the final image).

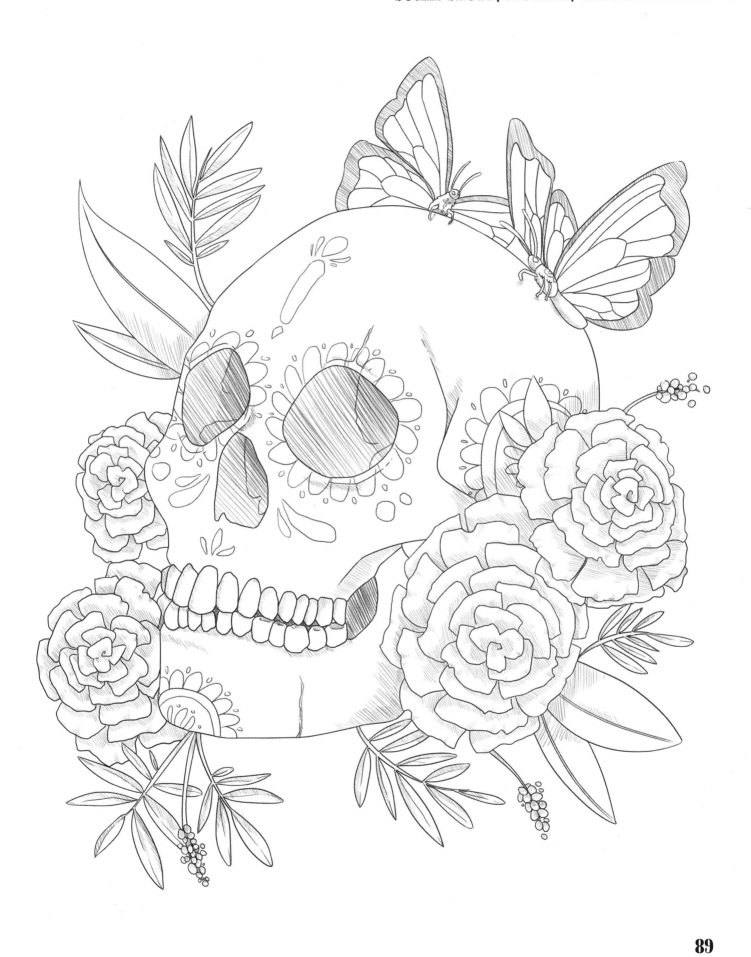

SKELETON MARIACHI BAND

Mariachi is a traditional Mexican musical expression dating back to the 18th century. The musicians (sometimes up to twelve in a band) usually play a mix of violins, guitars, harps, and brass and woodwind instruments, and are often depicted wearing elaborately decorated *charro* (Mexican cowboy) outfits.

STEP 1

If you've followed this book from start to finish, you will have learnt how to draw figures by themselves and in pairs. This image contains three full-size figures, some of which overlap, so it will be more difficult than most of the images in the book, but don't be discouraged! Begin by drawing in a baseline and movement lines for the figures. One of the figures will be crouching, so he will be shorter than the other two.

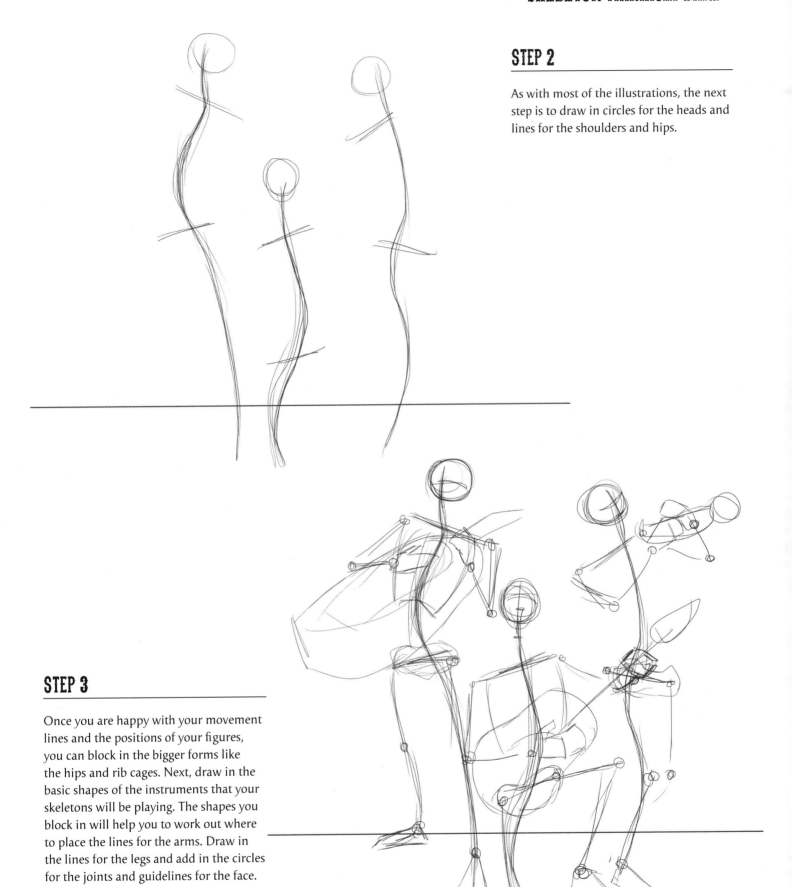

STEP 2

As with most of the illustrations, the next step is to draw in circles for the heads and lines for the shoulders and hips.

STEP 3

Once you are happy with your movement lines and the positions of your figures, you can block in the bigger forms like the hips and rib cages. Next, draw in the basic shapes of the instruments that your skeletons will be playing. The shapes you block in will help you to work out where to place the lines for the arms. Draw in the lines for the legs and add in the circles for the joints and guidelines for the face.

STEP 4

Now that you have your "wireframe", you can lightly erase it and start to block in the shapes of the clothing over the top. At this stage, there will be a lot of overlapping lines—don't worry, we will fix these up soon. Define the shapes of the instruments to make them more three-dimensional. Draw in the sombreros and start to block in the facial features.

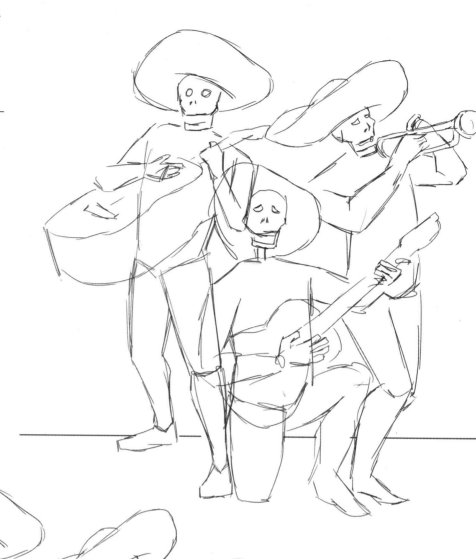

STEP 5

Once you have your figures blocked out, you can erase the lines from the figures in the background and any other guidelines you no longer need. You can grab a new piece of paper at this point if you wish. Start to shape out the hands and fingers and add in details to the clothing, such as the lapels and bows.

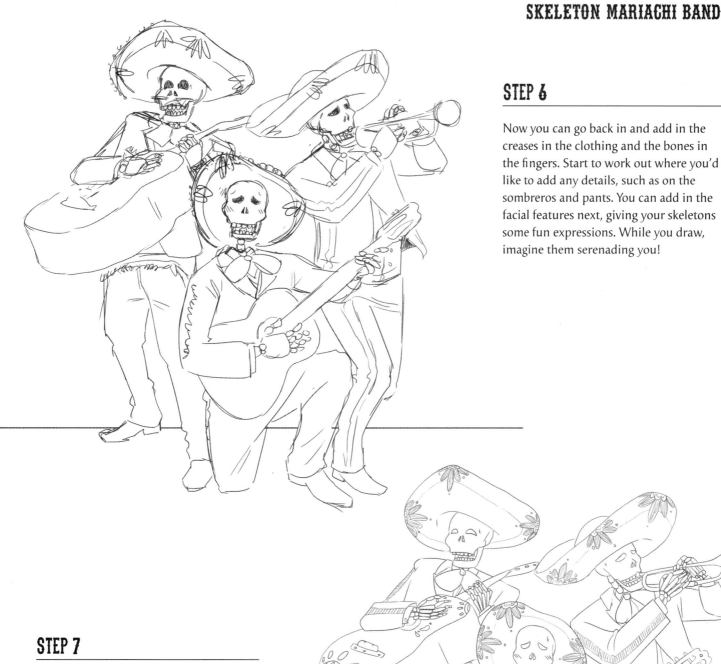

STEP 6

Now you can go back in and add in the creases in the clothing and the bones in the fingers. Start to work out where you'd like to add any details, such as on the sombreros and pants. You can add in the facial features next, giving your skeletons some fun expressions. While you draw, imagine them serenading you!

STEP 7

At this stage, you can either grab another piece of paper to do your final pass of the drawing on, or continue to work on the same one. Go back over your outline and neaten up the lines, fixing up any shapes you aren't happy with and adding in any other details you want to include. Decorate the outfits with festive decorations, as we did for the Catrina and Catrín illustrations (see pages 20–27). Use lots of swirls, triangles, circles, and teardrops—the sky's the limit with your decorations! Again, you can add as much or as little detail as you wish.

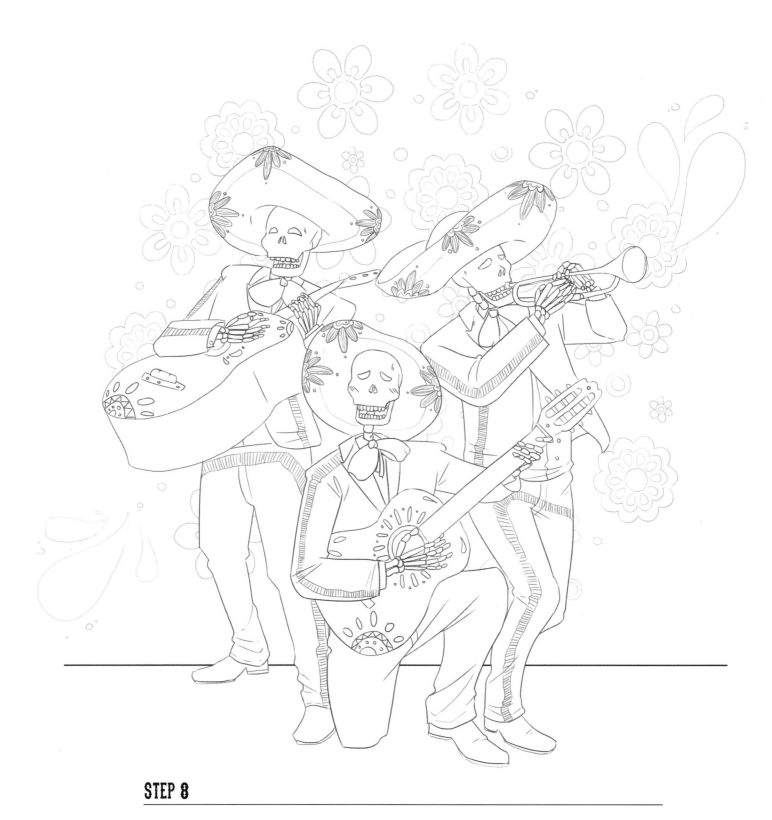

STEP 8

This step is optional, but now you can add in background elements. For this illustration, I have chosen some flowers and teardrop decorations. The flowers are made from a variation of circles, ovals, and teardrop shapes. You can create lots of different types of flowers with these shapes. A little shading brings the band to life (see the final image).

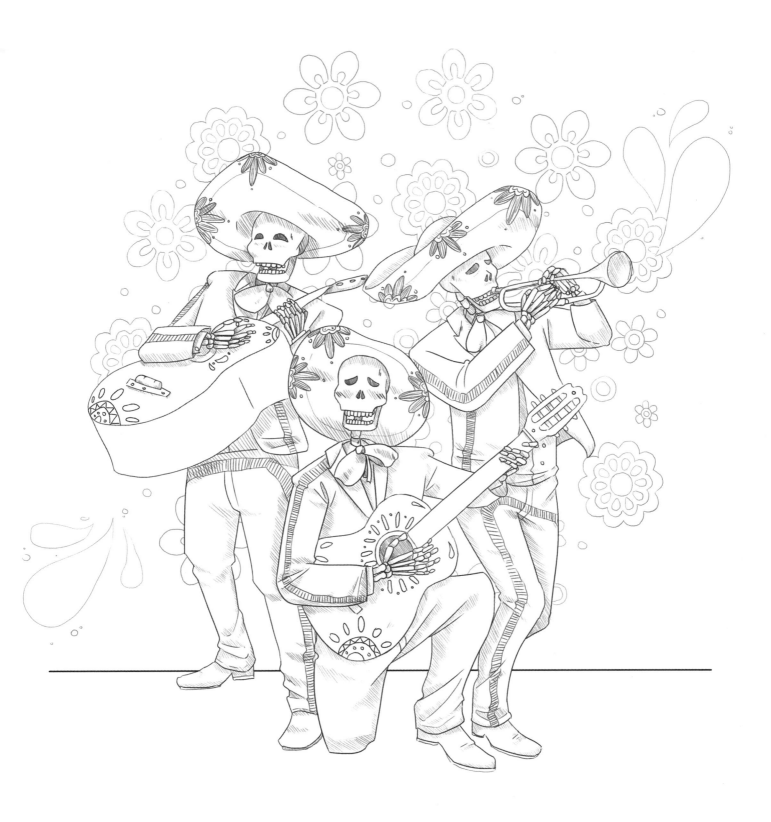

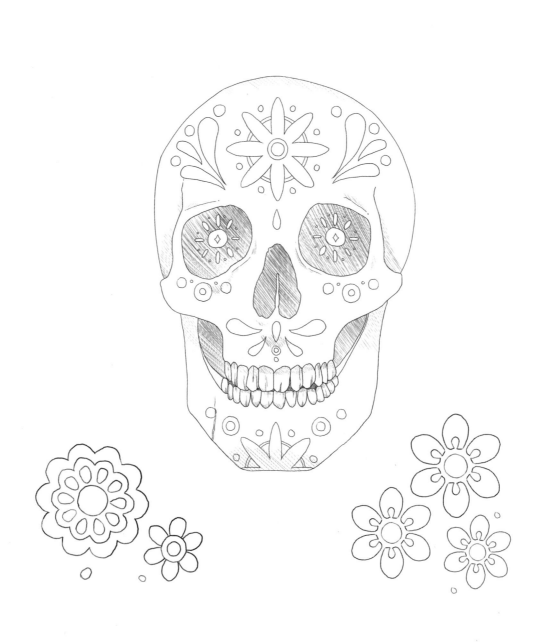